IMAGES
of America

HERSHEY

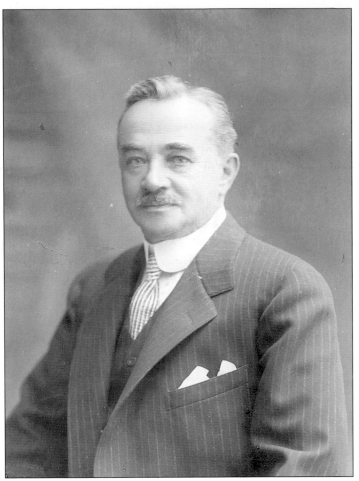

MILTON S. HERSHEY, 1910. At the time of this photograph, Milton Hershey's chocolate company was highly successful. His wealth was accompanied by a profound sense of moral responsibility and benevolence. For his workers he built a model town that included comfortable homes, a transit system, quality public schools, and extensive recreational and cultural opportunities. In 1909, he and his wife, Catherine Hershey, founded a school for orphan boys, and eventually he endowed the school with his entire fortune. He took great pride in the growth of his business, the school, and the town.

IMAGES
of America

HERSHEY

Mary Davidoff Houts and Pamela Cassidy Whitenack

ARCADIA
PUBLISHING

Copyright © 2000 by the M.S. Hershey Foundation
ISBN 978-0-7385-0436-0

Published by Arcadia Publishing
Charleston SC, Chicago IL, Portsmouth NH, San Francisco CA

Printed in the United States of America

Library of Congress Catalog Card Number: 00104051

For all general information contact Arcadia Publishing at:
Telephone 843-853-2070
Fax 843-853-0044
E-mail sales@arcadiapublishing.com
For customer service and orders:
Toll-Free 1-888-313-2665

Visit us on the Internet at www.arcadiapublishing.com

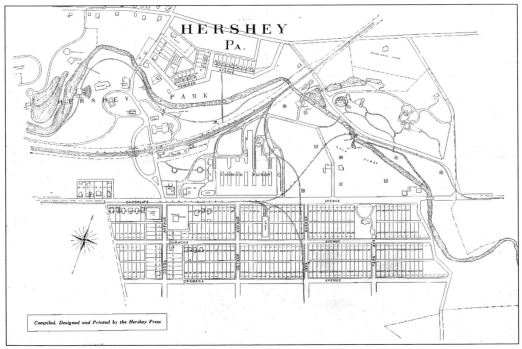

HERSHEY, C. 1910.

CONTENTS

ACKNOWLEDGMENTS

While much of this book was researched using the Hershey Community Archives' collection of materials, oral histories, and photographs, it would not have been possible to complete without the generous help of many community members and organizations. In particular, we would like to thank Neil Fasnacht for sharing his extensive collection of postcards and photographs, as well as for providing many leads for picture sources and for graciously answering questions whenever he was called upon. Dr. Joseph Brechbill at the Milton Hershey School's Historical Records not only opened the school's photograph collection to us but also provided answers to our many questions about the school's history. The Derry Township Historical Society provided us with much needed photographs of community organizations and individuals. Many other individuals and organizations generously allowed use of their photographs. We received them from the Chocolate Workers Local 464, Dauphin County Historical Society, Derry Presbyterian Church, Fishburn United Methodist Church, *Hershey Chronicle*, Hershey Entertainment and Resorts Company, Hershey Foods Corporation, Hershey Italian Lodge, Hershey Museum, Hershey Public Library, Hershey Theatre, Hummelstown Area Historical Society, *Lebanon Daily News*, Milton S. Hershey Medical Center, St. Paul's Lutheran Church, Gino Simonetti, and Spring Creek Church of the Brethren.

Many people freely shared their knowledge of the community and its history with us. They include the Reverend Dr. Richard Houtz, Derry Presbyterian Church; Kathleen Lewis, Derry Township Historical Society; Dick Hann, Milton Hershey School; Edward Small, Derry Township Department of Community Development; Ron Wix, Hummelstown Area Historical Society; Gretchen Moyer and Lucy Weekes, Milton S. Hershey Medical Center, Cathi Alloway, Hershey Public Library; Todd Pagliarulo, Hershey Entertainment and Resorts Company; Marcia Paterson, Milton Hershey School; Ken Gall, Hershey Trust Company; Carolyn Bibb, Richard Evans, Harold Good, Kenneth Hahn, Blaine Hess, Malcolm Hocker, Kenneth Hatt, William Jackson, Bud Prowell, Richard Mann, Sarah Miller, Carl Stump, and Charles Wolgemuth.

While the book was in draft form, we solicited input from a number of individuals. We are indebted to all the people who took time to read and comment on the manuscript. Many thanks to Joseph Brechbill, Helen Dodge, and Linda Miller, Milton Hershey School; Robert C. Vowler, Hershey Trust Company; John Long and Susan Smith, Hershey Foods Corporation; Matthew Loser and Kenneth Hatt (retired), Hershey Entertainment and Resorts Company; David L. Parke Jr. and Tanya Richter, Hershey Museum; Dr. Kimberly Carrell-Smith and Dr. John K. Smith, Lehigh University. Responsibility for the final text, including any factual errors or omissions, rests with the authors.

Letty Kohr and Ellen Peters, Hershey Community Archives, patiently pulled research materials for us, and Letty Kohr's work in assembling the photographs is especially appreciated. To those who made it possible for us to spend the extra time needed to work on the book, David L. Parke Jr., Lois Miklas, and Carole Ackerman of the Hershey Museum; Peter Houts and David Whitenack, we owe a special debt of thanks.

Throughout the book, credit to the owner of the photographs has been given. Images without a credit are from the Hershey Community Archives.

INTRODUCTION
ORIGINS OF A MODEL TOWN

On a blustery day in early March 1903, Milton Hershey watched as workers broke ground for a new factory. The location might have seemed odd to other manufacturers. Although the rail lines passed nearby, the area was largely rural and without the services or population to support a large and growing business.

However, Milton Hershey planned to build much more than a chocolate factory. Even as the crews were digging the foundations, engineers and architects were drawing up plans for an entire town. The idea of starting a company town was not new when he decided to build one around his new chocolate factory in rural Derry Township. However, Hershey's vision of what his "company town" would be was very different from what most people had learned to envision when they heard those words.

A by-product of the Industrial Revolution, company towns had existed for more than 100 years. In the early 19th century, the first industrial factories required waterpower to run the machines. Industrialists had to locate their factories in isolated locations by rivers and streams to gain access to their power source. Often these factories were not located near a town, and owners built rudimentary towns to provide housing for their workers. These first industrial factories were small, usually only employing 100 to 200 people. The introduction of steam-powered generators allowed factories to move from rural locations to the city. Industrialists were freed from having to supply housing, and they also gained access to large pools of workers.

The years following the Civil War saw an increasing rate of industrialization in America. This growth was fueled by the creation of a national network of railroads and telegraphs. The rapid and unplanned growth of cities was hastened by massive numbers of immigrants who came to the United States, attracted by the many jobs created by industrialization. As factories grew more mechanized and efficient, there was greater need for large numbers of unskilled workers. By 1900, some 90 percent of manufacturing was concentrated in urban areas. Industrialization changed the lives of millions of people, but for most of them change did not mean improvement. Although manufacturers, mine and ship owners, railway builders, and merchants made fortunes, there were few rewards for the people who worked in the factories. Urban factories polluted the water and air, creating unsanitary living conditions. Milton Hershey gained firsthand experience with some of the negative aspects of 19th-century urban life while working in Philadelphia and New York City during the 1870s and 1880s.

Industrialization also created new and increased demands for coal, iron, and steel. Like the early water-powered factories, these industries required that workers be brought to the source: to the coal and iron mines and steel mills. Unlike the early factories, these enterprises depended upon hundreds and thousands of laborers. Company towns built to house these workers were often erected without planning and without regard to the needs of the employees. Worker housing was often unsanitary and was tied to employment. Living in isolated locations, workers were usually dependent upon the company store for goods. The industries were also dirty and dangerous. The communities built for miners and steelworkers became known for their repression and squalor. In the steel industry, Sparrows

Point, Maryland, near Baltimore, was a typical company town, marked by gray smokestacks, polluted air, and rows of tenement shacks.

The dangerous work conditions created by industrialization led to increasing conflicts between workers and management. This tension was fueled by rapidly increasing immigration rates. Port cities teemed with people from many countries who were willing to work any job for low wages. During the late 19th century, worker unrest was marked by bloody and destructive strikes. Ironically, this era became known as the Gilded Age. The industrial revolution concentrated money and power into the hands of a small number of individuals who used it mainly for their own benefit and not for the improvement of the larger community.

Not all businessmen were so insensitive to their workers. During the 1880s, a growing number of industrialists began to realize that healthy and contented workers were an important part of a successful business. They paid attention to reformers who pointed to crowded and dirty cities as a source of workers' unrest. Enlightened businessmen believed that changing the living conditions for workers by building model industrial towns might create a contented and industrious working class.

While these towns were designed to improve the living conditions of workers, they were not developed out of pure altruism. The purpose of a model company town was to nurture workers so that they would be more productive. Industrialists who attempted to build model towns realized that providing clean and comfortable housing, recreational space, opportunities for education, and a healthy living environment would benefit them because the work force would then become more reliable. In other words, they reasoned that just as they purchased well-built machinery and invested in keeping it in good running order, they should also invest in maintaining the human machinery in their factories. Wise employers knew that directing part of their company profits toward the community would result in long-term benefits for the business as well.

Most model company towns included well-designed houses, parks, schools, libraries, and meeting halls, all set within an attractive landscape. These community facilities were gifts of the employer and a reflection of his town pride. Often, other towns of similar size could not afford these services and attractions.

An astute businessman, Milton Hershey traveled widely in the United States and Europe. Although he had a limited formal education, he was intelligent and curious. New ideas interested him. Model company towns springing up here and in Europe were publicized in the press and in business publications. Milton Hershey read such articles and probably visited some of the more famous model towns during his travels.

The most famous American company town was Pullman, Illinois. To people familiar with labor history, the word Pullman usually represents only labor strife, a bitter strike in 1894, and the autocratic control of town founder and owner George Pullman. But to Americans of the 1880s, the model town of Pullman represented innovation, enlightenment, and success. The Pullman community featured attractive and comfortable housing, water, electric and sewage service, tree-lined streets, a multipurpose arcade offering space for shops and services, and a large park for recreation.

In England, the confectionery firm Cadbury Company established Bournville, a model town for the benefit of its workers. Bournville offered workers a pleasant and healthful living space for a reasonable cost, plus opportunities for recreation and continuing education. These communities were built with an element of self-interest. Both George Pullman and the Cadbury brothers believed that upgrading the living environment would improve their workers.

Elements of Pullman and Bournville can be seen in the early development of Hershey. Like other model towns, Hershey provided its residents with a wholesome environment, modern educational facilities, and affordable housing. Hershey's vision for his town grew and evolved during his lifetime. Although not initially part of the town's design, its development as a tourist destination provided another source of income not dependent on the chocolate business. The strength of his vision enabled the town to prosper even after his death.

One

MILTON HERSHEY AND HIS FAMILY

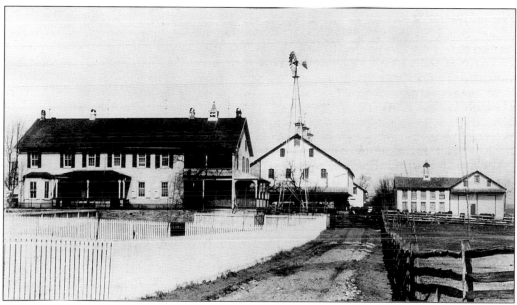

THE HERSHEY HOMESTEAD, 1897. This farm was built by Milton Hershey's great-grandparents, Isaac and Anna Hershey, in 1826. His parents, Fanny and Henry Hershey, were living with his grandfather, Jacob Hershey, when Milton Hershey was born there on September 13, 1857. He did not live there long, as his childhood was filled with frequent moves to different homes in Derry Township and nearby Lancaster County while his father pursued one unsuccessful business venture after another. The Homestead was sold after Jacob Hershey's death in 1877, in accordance with the terms of his will. When the house was put up for sale in 1896, Milton Hershey bought it back.

Milton Hershey's birthplace, Derry Township, is located in Dauphin County, the heart of rural central Pennsylvania. Both of Milton Hershey's parents, Veronica "Fanny" Snavely and Henry Hershey, were of Swiss Mennonite heritage. Religious persecution had driven the Snavely and Hershey families from Switzerland in the early 18th century. Milton Hershey's ancestors first settled in nearby Lancaster County. From the beginning, the Hersheys and the Snavelys were successful well-to-do farmers. In 1796, Milton Hershey's great-grandfather, Isaac Hershey, brought the family to Dauphin County, when he bought 350 acres of land in Derry Township. Some 30 years later, Isaac and Anna Hershey built their "Homestead." Their most famous descendant, Milton Hershey, was born there on September 13, 1857.

Hershey's parents were an unlikely couple. Henry Hershey had an alert and inquiring mind. Discouraged by his father from pursuing a proper education, his life story would be one of chasing dreams and financial failure. Fanny Snavely was practical and down-to-earth. The Snavely family was as well respected in Lancaster County as the Hersheys were in Dauphin County. After a brief courtship, the two were married on January 15, 1856. They seemed happy at first. As time passed, however, Fanny Hershey realized that her husband was not going to provide her with the financial security that she equated with success. Over the years of their marriage, they drifted farther and farther apart. Only their son held them together.

Milton Hershey's childhood was filled with frequent moves, as his father pursued one unsuccessful venture after another. Erratic and incomplete schooling was an unfortunate consequence for the son. In the eight years of his formal education, he attended at least seven schools. As an adult, he was self-conscious about his limited education and emphasized the need for a basic education in the local public school system and in his school for orphan boys.

Leaving school in 1871, he was apprenticed to a local printer. He did not like the work, and the apprenticeship ended quickly. With his mother's help, he next sought work with Joseph Royer, a Lancaster city confectioner. He had a natural talent for candy making. Following a four-year apprenticeship, he struck out on his own, opening a candy shop in Philadelphia during the 1876 centennial celebration. Despite much hard work and tasty products, his first business failed after six years.

Undaunted, he next traveled to Denver, Colorado, lured there by his father's glowing letters about the city's boom times and business opportunities. Unfortunately, his timing was wrong. Denver entered into an economic slump just before Milton Hershey's arrival. Needing money, he found work for a few months with a Denver confectioner and there learned an invaluable lesson—fresh milk made caramels chewier and more delicious. From Denver he traveled to Chicago and New Orleans, looking for a good opportunity to open his own business. Finding none, he headed to New York City. The New York venture started out well, but once again his business collapsed and Milton Hershey returned home to Lancaster. At this point his extended family turned their back on him, viewing him as being too much like his irresponsible and unsuccessful father. Undiscouraged, he started once again, making caramels under the trademark Crystal A at night and selling them by day. Thanks to an English importer who gave Hershey his first sizable order, the caramels became a sensation. Within four years, Milton Hershey was hailed as one of Lancaster's most successful citizens. The Lancaster Caramel Company shipped caramels throughout the United States and Europe, employing more than 1,400 people in four factories located in Pennsylvania and Illinois.

With financial success assured, Milton Hershey was able to pursue new interests. He began to travel abroad. Always curious and ready to pick up ideas from what he saw, he visited museums, shops, and tourist attractions. He walked the streets, watched the people, and is said to have kissed the Blarney Stone and gambled in Monte Carlo. In 1898, he surprised friends and family by marrying Catherine Sweeney, a first-generation Irish Catholic working girl from Jamestown, New York. She brought gaiety, wit, and warmth into his life.

The success of the Lancaster Caramel Company inspired Milton Hershey to seek out new challenges in candy making. He discovered a new direction while visiting the 1893 Columbian Exposition in Chicago. There, he saw a complete German chocolate manufacturing operation

in action. Mindful of trends in the confectionery business, he noted the growing market for chocolate and became convinced that his future was in producing it rather than caramels. He purchased the entire assembly and shipped it back to Lancaster at the end of the exposition. He installed the machinery in a wing of the caramel factory. It was here that Milton Hershey first experimented with making chocolate. He incorporated his new business as the Hershey Chocolate Company in 1894. At first he made cocoa, baking chocolate, and sweet chocolate coatings for his caramels. By 1895, he expanded to manufacture and sell more than 114 different products, most of them sweet chocolate in fancy shapes.

But it was the puzzle of making milk chocolate, at that time a luxury product made only in Switzerland, that really fascinated him. In the late 19th century, the formula for making milk chocolate was a secret closely guarded by Swiss confectioners. It took Milton Hershey several years to develop a viable formula for milk chocolate. Developing the formula for Hershey's milk chocolate was not a simple task. Bert Black, who began working for Hershey in 1899, remembered, "Nobody told Mr. Hershey how to make milk chocolate. He just found out the hard way."

Initially, milk chocolate experiments were conducted in Lancaster at the caramel factory. In 1896, Milton Hershey bought back the Hershey Homestead, the Derry Township farm on which he had been born. There, he built an experimental milk-processing plant. At the Homestead, he divided his time between the condensing room and the creamery, immersing himself in the difficult task of developing a viable formula for milk chocolate. Dressed in hip boots, he would go up into the second story of the creamery, put up a No Admittance sign, and stay there with his experiments sometimes for a day and a night, not even coming down for meals. There was no end to his experiments. After the milk-sugar mixture had been condensed, it would be shipped down to the chocolate factory in Lancaster.

Throughout the experimentation process, Milton Hershey was developing a vision for a new product, marketed and distributed in a new fashion. He envisioned a business that would mass-produce a limited number of milk chocolate products. This approach would keep production costs low and enable him to sell what had been a luxury product at an affordable price. Unlike the sweet chocolate product line that included confections made in dozens of shapes, Hershey's milk chocolate would be manufactured by machine in only a few shapes: bars, croquettes, and wafers.

After years of trial and error, Hershey finally worked out the recipe and necessary techniques. Introduced in 1900, Hershey's milk chocolate rapidly became a success. That same year, Hershey sold his Lancaster Caramel Company to competitors for $1 million (when an average salary was about $950 per year) and began to devote all his energies to making milk chocolate. Initially, it was produced in a wing of the old caramel company that had been retained following the sale of the Lancaster Caramel Company. It soon became clear that a new factory would be needed to keep up with the demand for his new product. Hershey searched the East Coast for a suitable site. He needed easy access to the Philadelphia and New York ports to receive cocoa beans and sugar. He needed a transportation network to ship finished products. Most importantly, the entrepreneur needed access to vast quantities of fresh milk. When Milton Hershey weighed all these factors, he decided to build his new chocolate factory near Derry Church, his Pennsylvania birthplace.

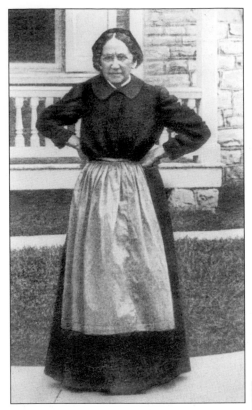

VERONICA "FANNY" HERSHEY, MILTON'S MOTHER, 1918. The youngest daughter of Abraham and Elizabeth Snavely, Fanny Snavely was born on September 4, 1835. Although raised in a Mennonite family, she did not join the church until after her marriage, probably in 1866. Throughout her life, she dressed in plain Mennonite clothes, in sharp contrast to her dapper husband.

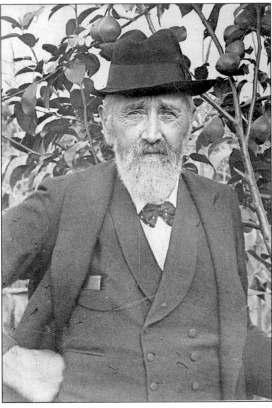

HENRY HERSHEY, MILTON'S FATHER, C. 1898. Born on January 4, 1829, Henry Hershey loved learning and books. His father discouraged his desire for a formal education, believing that a man should learn to support himself. He reluctantly accepted his father's plan but spent his life failing at each attempt at business. While not financially successful, he was creative, curious, and self-confident. He passed these essential traits on to his son.

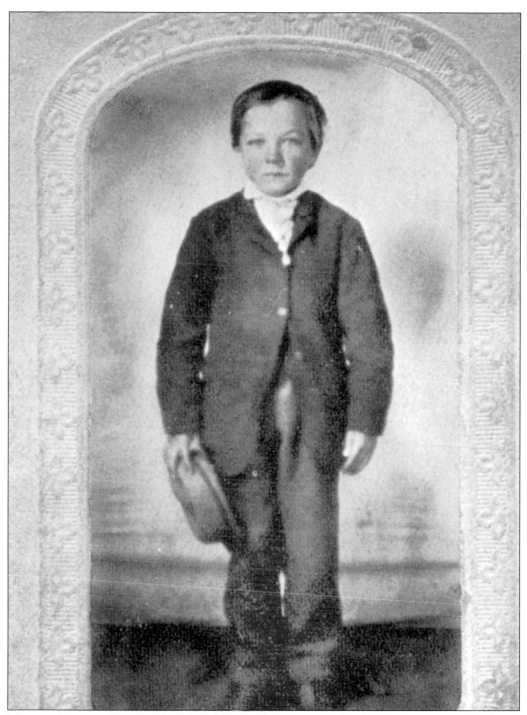

MILTON SNAVELY HERSHEY, 1864. Milton Hershey attended at least seven one-room schools during his eight years of formal education. Frequent disruptions resulting from family moves and a lack of natural inclination made the years of schooling hard for him. As an adult, Hershey's memory of his own limited education led him to provide better opportunities for his community's children.

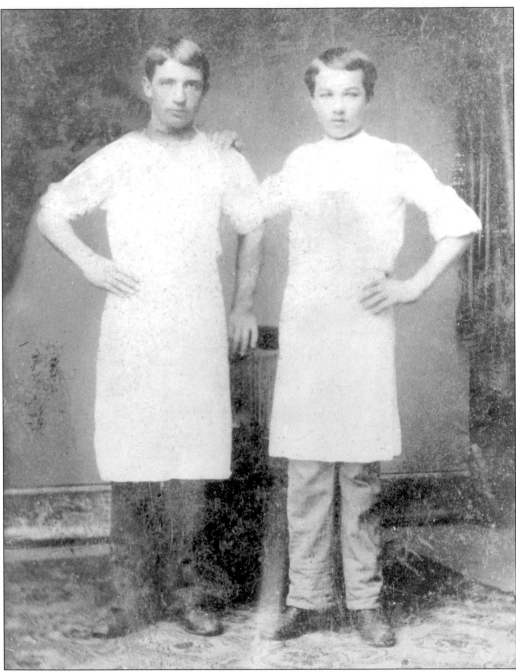

MILTON HERSHEY AND A FELLOW APPRENTICE, C. 1873. Following a short-lived apprenticeship with a printer, Milton Hershey began working for Joseph Royer, a well-known Lancaster city confectioner. During his four years there, Hershey learned the art of candy making. He had to learn the relationship between timing, temperature, and taste. He had a natural talent for mixing ingredients and soon excelled as a candy maker. Milton Hershey is pictured on the right.

M.S. HERSHEY
DEALER IN
FINE CONFECTIONERY, FRUITS, NUTS, &c.

MACHINERY HALL
LENGTH 1402 FEET WIDTH 360 FEET

No. 935 SPRING GARDEN STREET, PHILADELPHIA.

A BUSINESS CARD, C. 1876. Milton Hershey launched his first business venture in Philadelphia in 1876, opening a shop and wholesale business. He hoped to take advantage of the large crowds coming to celebrate the nation's centennial. His mother and Aunt Mattie eventually came to help him with the store. In spite of much hard work and financial support from his relatives, the business failed after six years.

MARTHA "MATTIE" SNAVELY, C. 1865. Milton Hershey's Aunt Mattie was one his strongest supporters. During her lifetime she used her money to support his early businesses and also worked for him, wrapping candies and tending the counter at his shops. When the rest of his family refused to support him any more, she offered her home as collateral so that he could start the Lancaster Caramel Company. She lived to see him finally achieve success before her death in 1894.

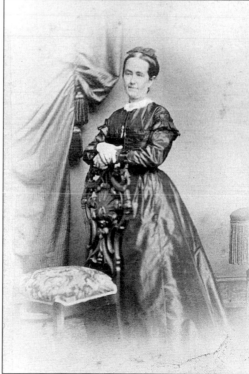

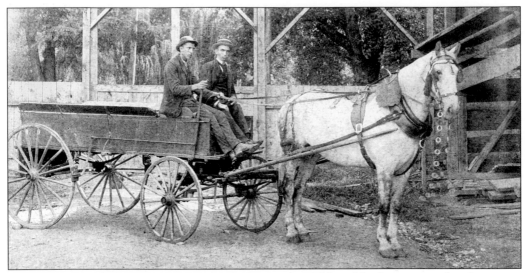

JOHN OTTO AND HIS WAGON, C. 1885. A penniless Milton Hershey returned to Lancaster after his second business failed, shipping his candy equipment collect to the train station. Undaunted, he laid plans for a new business. After a friend paid the freight costs, Hershey asked a local drayman, John Otto, to haul the equipment to his shop, promising payment later. Otto agreed, and a month later Milton paid him his fee of 50¢.

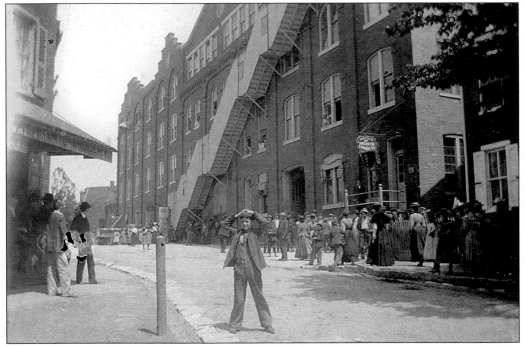

THE LANCASTER CARAMEL COMPANY, C. 1898. Milton Hershey's Lancaster enterprise first operated out of a small room in a large Church Street factory building. His business was sandwiched between a brewery and a carriage works, with an organ factory and a carpet-beating business nearby. The business grew rapidly and by 1892, the factory occupied not only the entire building but most of the city block as well: 450,000 square feet of floor space. (Courtesy of Historical Records, Milton Hershey School.)

MILTON S. HERSHEY, 1887. A year before this picture was taken, Hershey was penniless with only his belief in himself emboldening him to start a new business. Soon after he started the Lancaster Caramel Company, an English importer placed a large order for his caramels. His trademark product, Crystal A caramels, became an instant success. By 1894, Milton Hershey was described as one of Lancaster's most substantial citizens.

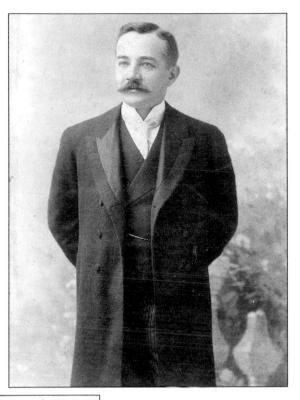

Caramels Only.

Consisting of THIRTY VARIETIES.

THE ONLY ORIGINAL UNWRAPPED CARAMELS

PACKED 196 IN A BOX,

ARE MANUFACTURED BY THE

Lancaster Caramel Company,

LANCASTER, PA.

N. Y. Office, 383 Canal Street.

❖ ❖ And bear the Trade Mark, ❖ ❖

CRYSTAL A CONFECTIONS

❖ ❖ All others are imitations. ❖ ❖

Insist on having this brand if you wish to increase your trade on Caramels.

A LANCASTER CARAMEL COMPANY ADVERTISEMENT, OCTOBER 1892. The company's product line included caramels priced for different markets. They ranged from bean-shaped McGintys, which sold to children at ten for a penny, through the medium-grade Jim Crack and Roly Poly, to the top-grade Lotus, made with whole milk and cream. When Milton Hershey sold the caramel company in 1900, it was the leading manufacturer of caramels in the United States.

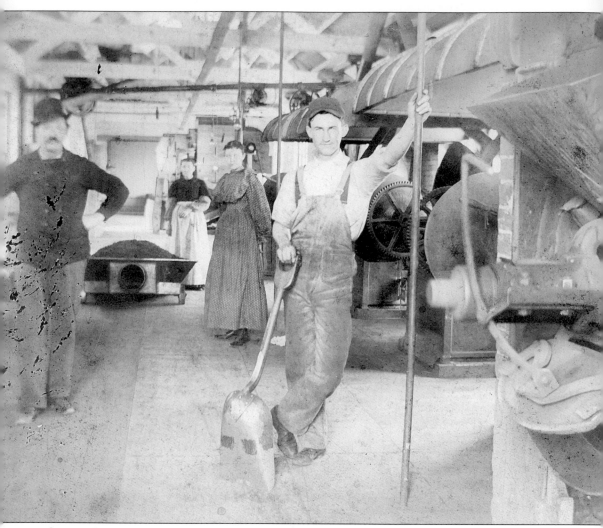

COCOA BEAN ROASTERS, HERSHEY CHOCOLATE COMPANY, LANCASTER, PENNSYLVANIA, c. 1900. Discovering an exhibit of chocolate-making machinery at the 1893 Columbian Exposition, Milton Hershey purchased it and shipped it to Lancaster. The equipment was set up in a wing of the caramel factory. It was here that he first experimented with the chocolate-making process. At first he produced chocolate coatings for his caramels. Within a year he was also producing cocoa, baking chocolate, and sweet chocolate in a variety of shapes and sizes. When Hershey sold the Lancaster Caramel Company in 1900, he retained the factory wing that held the chocolate-making equipment and the right to manufacture chocolate. Hershey's Milk Chocolate was manufactured here until the new factory was completed in 1905.

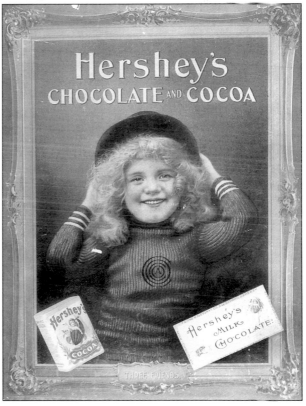

A HERSHEY CHOCOLATE COMPANY INVOICE, 1899. When Hershey first began making chocolate, he made sweet chocolate novelties in a variety of shapes and sizes. A 1899 product list recorded more than 200 different products, varying in formula, shape, and packaging. The product names ranged from whimsical ones, such as Zookas and Bicycles, to ones that suggested an upper-class lifestyle, such as Grand Duchess, Petit Bouquets, and Princess Wafers. These products were manufactured in the Lancaster plant until it closed in 1909.

THREE FRIENDS, C. 1900. The Swiss introduced milk chocolate as an expensive luxury product in 1876. When Milton Hershey began making milk chocolate, he broke new ground, mass-producing it in only a few shapes. This allowed him to sell his product for only 5¢, making a luxury product affordable to all. He found new markets for his product, selling it in grocery stores, newsstands, and vending machines. In-store displays promoted Hershey products. (Courtesy of Hershey Museum.)

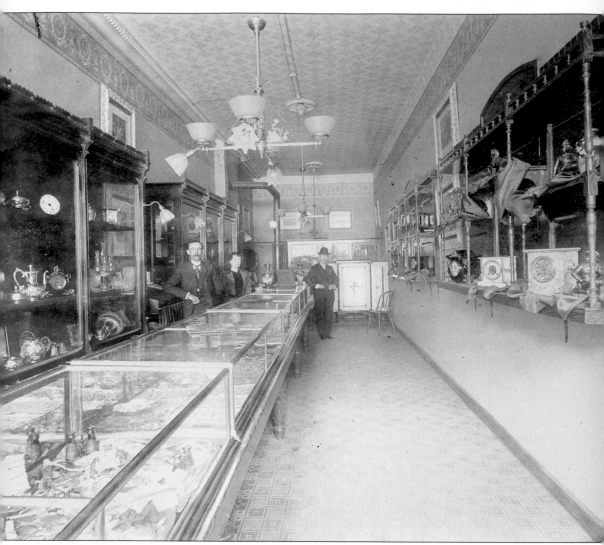

A JEWELRY STORE, JAMESTOWN, NEW YORK, C. 1896. As the oldest daughter of Irish Catholic immigrant parents, Catherine "Kitty" Sweeney was the second of four children. In 1888, she left high school to start work in a jewelry store. As a shop girl, she worked long hours, six days a week. In 1897, Milton Hershey met Catherine Sweeney at a local confectionery and soda fountain while making sales calls. The attraction was immediate. During the time of their courtship, she moved to New York City and found work in the ribbon section of Altman's Department Store. The following year, the two were married in the rectory of St. Patrick's Cathedral, New York City. Catherine Sweeney is pictured second from left. (Courtesy of Historical Records, Milton Hershey School.)

CATHERINE SWEENEY HERSHEY, C. 1900. Milton and Catherine Hershey were married on May 28, 1898. The wedding was a surprise to his mother and friends, who considered him a confirmed bachelor. However, the marriage was good for both of them. A beautiful woman, she brought joy and companionship to him. He gave her security and love. Every day of their marriage, he brought her fresh flowers. The Hersheys were truly a happily married couple, and they looked forward to their life together.

222 SOUTH QUEEN STREET, LANCASTER, C. 1900. Milton Hershey bought this spacious home, following the success of his caramel company. He remodeled the house and landscaped the property, filling it with exotic birds, plants, and mementos of his travels. He also entered Lancaster society, joining organizations such as the Tally-Ho Club and the Hamilton Men's Club. He and his wife lived here until the new chocolate factory opened in 1905.

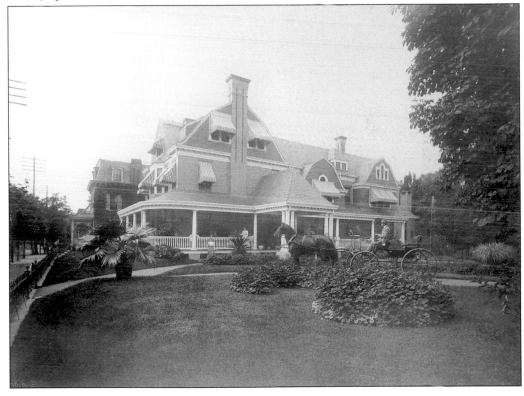

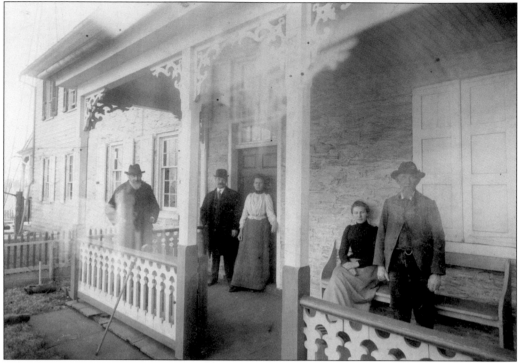

THE HOMESTEAD, C. 1898. Milton Hershey brought his father back to live at the Homestead after he purchased it in 1896. Until his death in 1904, Henry Hershey relished his son's success. During his last years, the father often was seen riding about in a horse and buggy and dressed in a frock coat and silk hat. He spent his days reading, discussing ideas, and conducting agricultural experiments. Pictured, from left to right, are Henry Hershey, Milton Hershey, Laura and Lena Slesser, and Josiah Shenk.

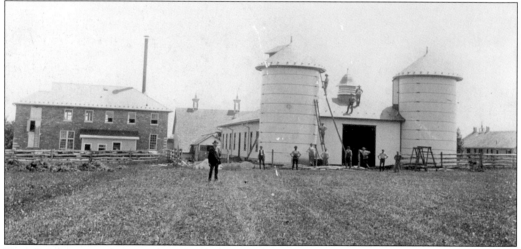

THE EXPERIMENTAL PLANT, THE HOMESTEAD, C. 1901–1904. Even after Hershey's milk chocolate was introduced in 1900, Milton Hershey continued to test and tinker with his formula and the process of condensing milk for his chocolate. At the Homestead milk-processing plant, he experimented with mixing milk and sugar and condensing it. Batches of condensed milk were shipped to Lancaster and used in attempts to improve the milk chocolate.

Two

DERRY TOWNSHIP
1857–1902

THE OLD DERRY CHURCH AND THE SESSION HOUSE, EARLY 1880s. This church and the smaller Session House were already well over 100 years old in the early 1860s, when Milton Hershey was a small boy living in Derry Township. By the time Hershey moved back to the area in the early 1900s, the congregation had replaced the badly deteriorated old church with a new limestone chapel. Hershey built his chocolate factory and his home next to the church grounds. (Courtesy of Derry Presbyterian Church.)

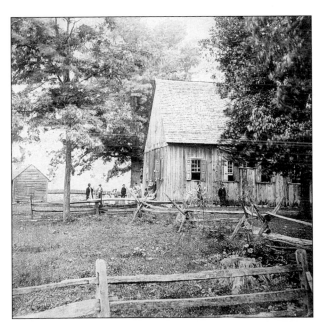

Central Pennsylvania's serene and fertile Lebanon Valley, where Milton Hershey chose to build his new chocolate factory, had attracted people for hundreds of years. Bands of Native Americans, who used the area as hunting grounds, were the first human beings to come. Their legacy was place names and the stone projectile points uncovered by later farmers' plows. In the early 1700s, Scots-Irish immigrants came, lured by Pennsylvania's reputation for spiritual tolerance. Here, they established a community and named it Derry for the town they had left behind in Ireland. The future site of Milton Hershey's factory was close to this little farming community, which had come to be known as Derry Church. The local township also was called Derry. After the American Revolution, many of the Scots-Irish residents moved away, attracted by opportunities on the western frontier. By the time of Milton Hershey's birth there in 1857, Derry Township's population consisted mainly of the descendants of Swiss and German immigrants. They came to Pennsylvania in the 18th and early 19th centuries for a variety of reasons—some, like Milton Hershey's ancestors, seeking religious tolerance, some a better way of life.

Pennsylvania Germans, *Deutsch* or Dutch as they came to be called, had a well-deserved reputation as thrifty and prosperous farmers. Most of the farms in Derry Township, including that of Milton Hershey's grandparents, were large and productive. The primary crops were wheat, rye, corn, and hay. Dairying, also an important part of farm operations, was done by the farm women. They milked the cows, made butter from the cream, and fed the leftover skim milk to the swine. The butter was bartered for other goods or sold at market.

Farms dominated the Lebanon Valley in the mid-1800s. In the 27-square-mile area of Derry Township, the rural scene was broken only by a few crossroad clusters of houses, plus Derry Church and a few other villages. Country churches, one-room schoolhouses, gristmills, and sawmills punctuated the landscape at intervals. In the distance to the north were the foothills of the Alleghenies, locally called the Blue Mountains because they appeared to be a deep blue-green for much of the year. Closer, and to the south, the lower sand hills made a border—part woods, part farm—for the gently undulating countryside. Many small streams and larger creeks crisscrossed the area as they drained toward the mighty Susquehanna River, 13 miles to the west.

Almost 80 percent of the township's population of 2,300 worked at farming. The rest were small-scale artisans who labored, with one or two helpers, at trades that supported the rural community. Water-run sawmills and gristmills served local needs. The limestone and brownstone deposits in the township were quarried on a relatively small scale. Limestone was used as a building material and was heated in kilns to make lime fertilizer. Brownstone was used mostly for public works, such as the enlargement of locks on the nearby Union Canal, bridges, and culverts for the first local railroad.

Before construction of the Lebanon Valley Railroad in 1858, Derry Township was connected to the rest of Pennsylvania only by the Reading and Horseshoe Turnpikes and the Union Canal. Farm wagons and stagecoaches used the turnpikes to carry local produce and passengers to nearby cities. The canal was part of a system that connected the eastern and western portions of the state with the northern coal regions. It brought coal and lumber to Derry Township and carried local goods to market. Eventually, the railroad superseded both the turnpikes and the canal as the primary route to the outside world.

The railroad and an increasing number of other technological innovations had a significant impact on life in the Lebanon Valley as the 19th century progressed. By 1903, when Milton Hershey started building his new chocolate factory, economic and social conditions were very different from the way they had been at the time of his birth.

Following the Civil War, farming became more commercialized. The number of individual farms in the township decreased, although the total acreage remained the same. Commercialization meant that farms were more influenced by conditions outside the valley. The railroad opened up new and more distant markets. For example, products such as poultry, calves, and watercress from Derry Township were routinely shipped to New York City. But the railroad also brought competition, as farm products from the western states became more available. Local

gristmills, for instance, had difficulty competing with flour milled in the Midwest. Local use of technological innovations changed farm practices in the township. Commercial dairies, using newly invented equipment, largely took over the production of butter from the farm women. Developments such as silos for the storage of winter feed meant that milk cows could be kept in production year-round. This, coupled with the introduction of milk pasteurization, helped make fresh milk an important commercial commodity.

The Industrial Revolution began to have noticeable effects. Nonfarm industries became larger and more varied, providing many farm youths with alternative means of employment. By 1900, Hummelstown, the largest village in the township, had doubled in size to 1,700 residents, as people settled there to be closer to employment in its shirt, shoe, cigar, and stocking factories. Even little Derry Church had a flour mill, a shoe factory, and a steam noodle factory in the 1890s.

These were small operations, however, compared to the stone quarry industries that expanded with the coming of the railroad. By the latter 1800s, brownstone quarrying had become the largest industry in Derry Township. Hummelstown brownstone was shipped throughout the eastern United States and even farther afield. Many of New York City brownstones were built from this stone. By 1896, there were at least a dozen quarries employing a total of 500 to 700 men. Related industries such as stonecutting provided additional employment. The influx of quarry workers brought new ethnic backgrounds to this once solidly Pennsylvania German region. Recent immigrants, mainly Hungarian, plus migrant African Americans from Virginia, made up the majority of the day laborers at the quarries and stone mills. Most were transient workers, but a small group of stonecutters, almost all Italian, brought their families and settled in the area.

All these changes made Derry Township an ideal place for Milton Hershey to build his new chocolate factory. The local population had a strong work ethic. The surrounding farmland could easily produce the vast quantities of fresh milk he needed. The economy already had begun to shift to commercial dairying and nonfarm employment. Highly qualified stoneworkers could provide important construction skills. The railroad was in place, providing the essential transportation system to deliver raw materials and to ship finished goods. There was ample, good-quality water. Most importantly, the undeveloped site offered Hershey the opportunity to build a complete town along with the chocolate factory. In late 1902, a real estate agent quietly began buying farmland on behalf of Milton Hershey, and on March 2, 1903, workers broke ground for his new factory.

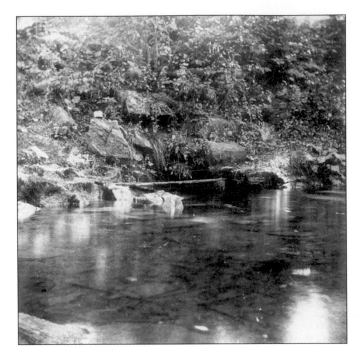

THE DERRY CHURCH SPRING, EARLY 1900S. Derry Presbyterian Church was built near this fine spring in the early 1700s. For 200 years, it served residents of the town of Derry Church. Eventually, it became part of the water supply for the Hershey chocolate factory. The spring's copious flow diminished in the late 1940s, when the area's groundwater level was lowered. (Courtesy of Neil Fasnacht.)

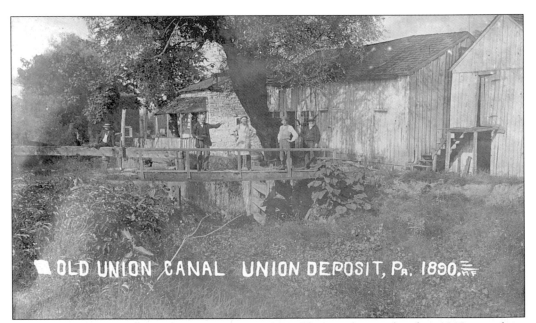

THE OLD UNION CANAL, UNION DEPOSIT, 1890. The canal, completed in 1827, ran along the northern border of Derry Township. It provided an east–west transportation route from the Schuylkill River to the Susquehanna River, as well as a connection to the north. Local farmers and businesspeople found the canal useful, but by the early 1880s competition from the railroad put the Union Canal out of business. (Courtesy of Neil Fasnacht.)

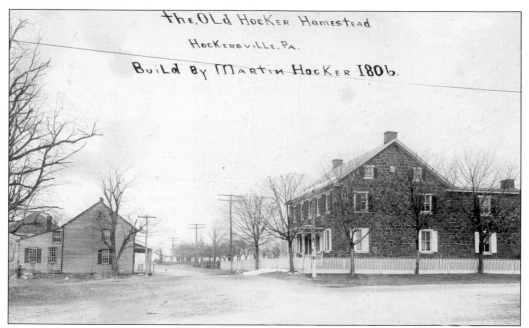

The, OLd HocKer Homestead
HocKersviLLe, Pa.
BuiLd By Martin HocKer 1806.

THE MARTIN HOCKER HOUSE, EARLY 1900s. This house, built of local brownstone by Martin Hocker in 1806, is located on the old Horseshoe Turnpike some 3 miles west of Milton Hershey's birthplace. It is thought to have been used by travelers on the pike as an inn during the 19th century. The crossroads village of Hockersville, just to the north, took its name from the Hocker family. (Courtesy of Neil Fasnacht.)

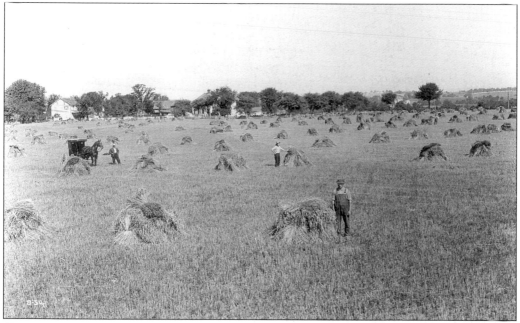

HARVESTTIME, DERRY TOWNSHIP, C. 1901. The sheaves of wheat shown here in shocks ready for thrashing are on one of the farms that had been recently purchased by Milton Hershey. The man standing next to the horse and buggy is probably Milton Hershey's first farm supervisor. (Courtesy of Historical Records, Milton Hershey School.)

27

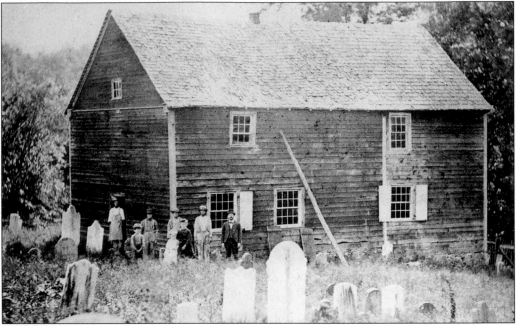

ST. PAUL'S LUTHERAN CHURCH, C. 1860–1874. Commonly called the Sand Hill or Hill Church, this building was erected in 1756 by Pennsylvania German inhabitants of Derry Township. Weatherboarding was added to the original log structure in 1826. A sandstone church was erected in its place in 1875. In the early years, all services were in German. Alternation of German and English services continued until 1902. (Courtesy of St. Paul's Lutheran Church.)

THE STOVERDALE CAMP MEETING GROUNDS, EARLY 1900S. Stoverdale, 3 miles south of Hummelstown, had been a popular camp meeting site for United Brethren Church members since 1866. Thousands of people came, mostly by train, to the ten-day religious programs each summer. Many set up tents or had cottages on the campgrounds. (Courtesy of Neil Fasnacht.)

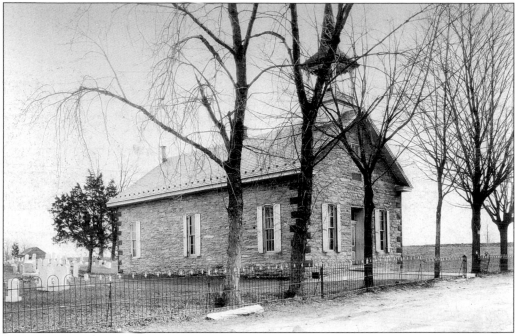

THE FISHBURN UNITED METHODIST CHURCH, SECOND CHURCH BUILDING, DEDICATED 1887. The Fishburn United Methodist Church was founded in 1846. Derry Township's four other pre-Civil War churches were organized in the 1700s. All five churches built handsome replacements for their original modest buildings in the 1870s and 1880s, as Derry Township citizens grew more prosperous. (Courtesy of Fishburn United Methodist Church.)

THE SPRING CREEK CHURCH OF THE BRETHREN, SECOND MEETINGHOUSE, BUILT 1886. An outgrowth of the original group who came from Germany to Pennsylvania to escape persecution, the Derry Township Brethren congregation continued to expand. They met in private homes until a small meetinghouse was built in 1848. The congregation's continued growth made the 1886 building necessary. (Courtesy of Spring Creek Church of the Brethren.)

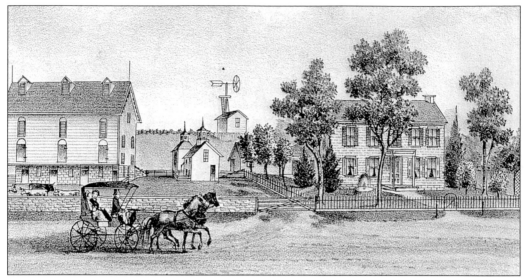

THE J.H. BALSBAUGH RESIDENCE, SWATARA STATION, 1875. John H. Balsbaugh, a prosperous dealer in coal, grain, and general produce, owned a warehouse near the Swatara railroad depot, about a one mile west of Derry Church. During the last quarter of the 19th century, he and other Derry Township merchants owed some of their business success to technological advances in farming, which increased local productivity.

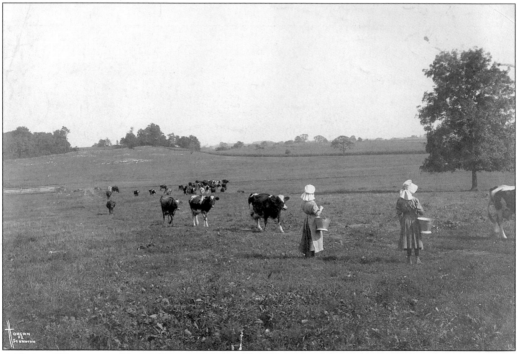

A DERRY TOWNSHIP FARM, LATE 19TH OR EARLY 20TH CENTURY. On Pennsylvania German farms, dairying was traditionally the responsibility of women who made butter and cheese at home and sold it at market. By the late 19th century, although women still worked with the cows on the farm, dairy products were produced commercially in factories run by men. At this same time, dairy-pasteurized milk was becoming a commercial commodity.

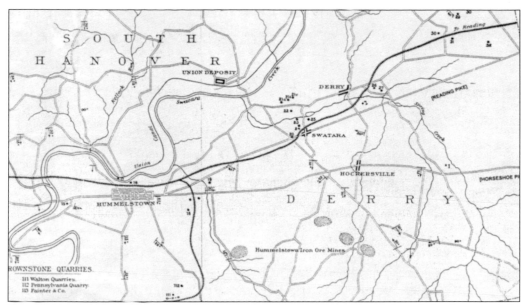

Derry Township, 1886. The numbers on this map from the *Atlas of the Report of the Pennsylvania State Geologist, 1886–1888*, refer to the numerous limestone quarries and large brownstone quarries located in the township. Two symbols have been added: No. 1 marks the location of Jacob Hershey's farm, birthplace of Milton Hershey; No. 2 marks the site of the future Hershey chocolate factory.

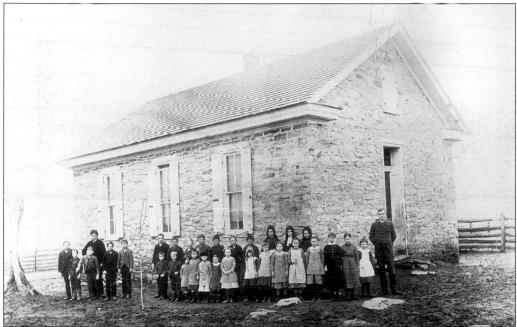

The Greiner School, c. 1904. In the early 1860s, Milton Hershey attended three Derry Township one-room schools, including this one. One-room schools were the norm for rural public school districts at the time. This school was located on what was to become the corner of Cocoa and Chocolate Avenues in the town of Hershey. Note the local limestone used in its construction.

31

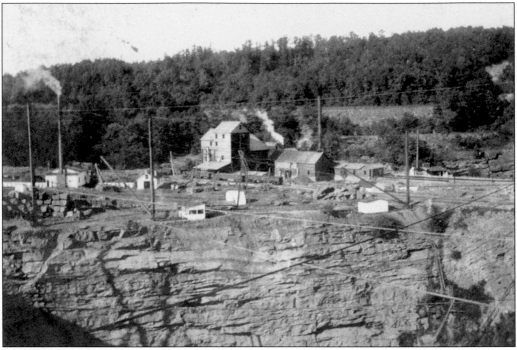

A BROWNSTONE QUARRY, EARLY 1900S. Derry Township's best-known product in the late 19th century was Hummelstown brownstone. This fashionable building stone quarried in the hills south of Hummelstown was durable and relatively easy to work. It was shipped to many East Coast locations and west as far as Illinois. (Courtesy of Neil Fasnacht.)

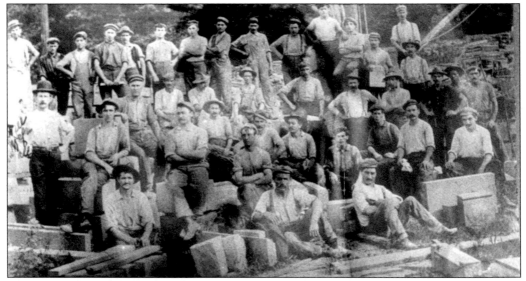

STONECUTTERS, HUMMELSTOWN BROWNSTONE COMPANY, C. 1900. Brownstone quarries were the largest employers in Derry Township until the Hershey chocolate factory opened. Many of the highly skilled stonecutters were Italian immigrants. Along with other recent immigrants and migrant laborers from the South, most lived in the village of Waltonville, which grew up around Allen Walton's large quarry operation. (Courtesy of Hummelstown Area Historical Society.)

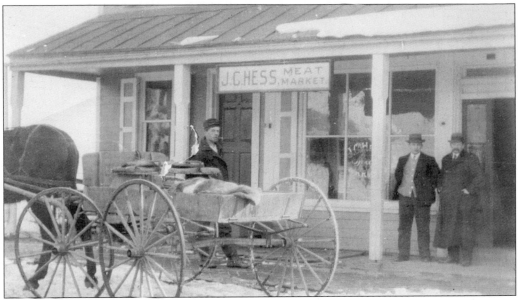

THE J.C. HESS MEAT MARKET, WALTONVILLE, EARLY 1900S. Jake Hess catered to the Waltonville housewives and boardinghouse keepers. The community also had a school, a church, a company store, and a post office. Waltonville became a ghost town after the quarries closed in 1929. Hess was among its former residents who moved to the new town of Hershey. (Courtesy of Derry Township Historical Society.)

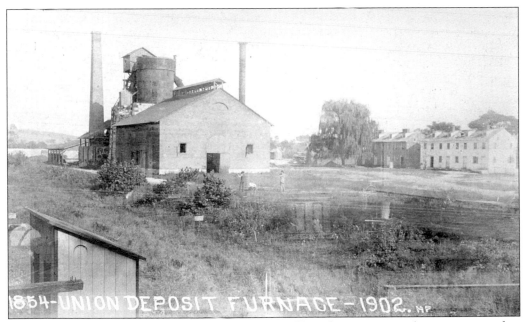

THE UNION DEPOSIT IRON FURNACE, 1902. Derry Township iron ore and stone were used in this blast furnace in a nearby township from 1854 to 1887. Limestone from a Swatara quarry and high-quality iron ore from shallow veins in the Sand Hills were hauled here, first by horse and wagon and later by railroad. The furnace was dismantled in 1902. Iron mining in Derry Township ceased around the same time. (Courtesy of Neil Fasnacht.)

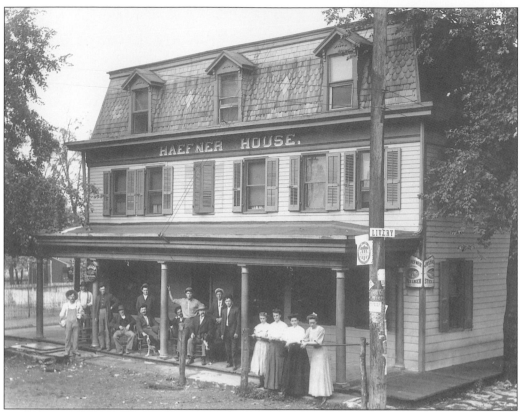

THE HAEFNER HOUSE, DERRY CHURCH, C. 1910. This hotel was located on the main street of the little village of Derry Church. In 1904, when 20 employees of Milton Hershey's Lancaster chocolate plant came to work in the new chocolate factory, they found rooms here. There was no other place to accommodate them in the heart of rural Derry Township.

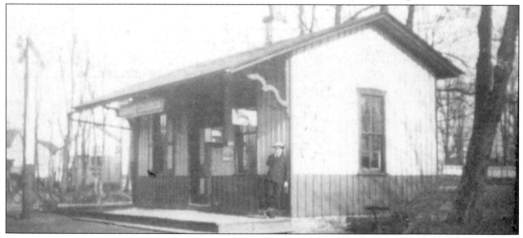

THE DERRY CHURCH RAILROAD STATION, EARLY 1900s. The Lebanon Valley Line of the Philadelphia and Reading Railroad, running east and west between Reading and Harrisburg, was ready for operation in 1858, the year after Milton Hershey was born. This station served the people of Derry Church until 1906, when a new station was built close to the Hershey chocolate factory. (Courtesy of Neil Fasnacht.)

Three

THE FIRST TEN YEARS
1903–1913

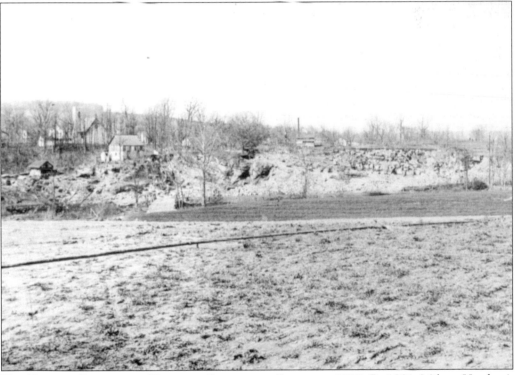

THE FUTURE SITE OF THE HERSHEY CHOCOLATE FACTORY, 1903. By 1901, Milton Hershey's chocolate business had outgrown his original factory in Lancaster. In planning for a new factory, Hershey considered sites in Lancaster, Baltimore, New Jersey, and New York. In the end he decided to build the factory in the countryside and chose his birthplace, Derry Township.

While his associates questioned the wisdom of building a factory in rural Derry Township, Milton Hershey had a much larger vision than simply building a chocolate industry. He was part of a forward-looking group of entrepreneurs in this country and abroad who believed that providing better living conditions for their workers would result in better workers. Hershey drew his ideas from many model town experiments, including those of George Pullman and the Cadbury brothers in England. He developed his plans during a time when progressive values and goals were advocated by many different segments of the population. The Progressive movement was an attempt to address the social, economic, and cultural problems created by the rapid growth of the industrial age. While different groups advocated solutions that were sometimes conflicting, they all were responding to the dramatic changes in living and working conditions taking place during the latter half of the 19th century. During these years, the U.S. population rapidly shifted from being largely rural to being concentrated in cities and large towns. Often, living conditions in the cities were impaired by inadequate sanitation, low-quality water, and cramped housing. Milton Hershey conceived of building a community that would support and nurture his workers. Developing the community became a lifelong passion for him.

The farmland that Milton Hershey chose as the site for the new chocolate factory was located one-third of a mile south of Derry Church's main street. The Derry Church Spring and Spring Creek ran through the site. A limestone quarry to supply construction materials was nearby. The Lebanon Valley Railroad ran alongside the construction site. Milton Hershey negotiated with the Pennsylvania and Reading Railroad Company to relocate the Derry Church station, giving them the land on which to put it. On March 2, 1903, workers broke ground for the factory. In accordance with Hershey's plans, the new factory was specifically designed and built to manufacture a limited number of products in the most efficient way possible. The chocolate factory was completed in June 1905 and began producing milk chocolate that summer.

While the factory was under construction, the footprint for the rest of the town was developed. Space was allocated for industry, a shopping district, recreational facilities, and residences. Milton Hershey's desire to build a community that was functional and attractive led him to hire professionals to oversee the town's design. Noted Lancaster architect C. Emlen Urban designed all the major structures and dwellings in town, including Milton Hershey's own home, High Point. Renowned landscape architect Oglesby Paul, responsible for the design of Philadelphia's Fairmount Park, was hired to develop a landscape plan for the town and the future park. The infrastructure of the entire community was mapped out by Lancaster engineer H.N. Herr. Milton Hershey's vision for the new community was well thought out. While the appearance of different parts of the vision evolved over time, the components were all laid out during the first ten years. From the beginning, Hershey sought to create a healthy and attractive environment that would protect the residents from the evils of congested city life.

To encourage employees to have a personal stake in the new community, Hershey not only built homes for rent but also offered lots for sale. The development of these lots was controlled by deed restrictions that dictated front and back lawns and prohibited the inclusion of outhouses, chicken coops, pigpens, or businesses such as tanneries and glue factories. Hershey paid homage to chocolate, naming the streets after cocoa-growing regions in the world.

Milton Hershey felt it was essential that residents have a sense of freedom living in this new community. He did not want his workers to feel isolated or restricted to shopping in the company-run businesses. Before the factory was completed, he began constructing an extensive trolley transit system that linked the town to the surrounding communities. The trolleys served two purposes: they were an important means of bringing milk to the factory, and they provided inexpensive transportation for workers living outside of the town. Trolleys also made it possible for residents to shop in and visit nearby towns.

Milton Hershey's vision for his new town stretched beyond providing the bare essentials. He sought to provide a wide array of services that would make Hershey an attractive and livable community. He provided for a local bank, a laundry, a blacksmith shop, a printing plant, a café, a department store, a post office, and a barbershop. He also started companies to provide water,

electric, sewage, and telephone service—services not always available in small rural towns of the era. In addition, he provided recreational facilities including an indoor pool, a gymnasium, and a public library. In 1909, he launched the *Hershey Press*, a weekly newspaper.

The town was not an official entity and remains unincorporated to this day. There were no official boundaries. The Derry Township Board of Supervisors was nominally in charge of governmental functions. During his lifetime, however, Milton Hershey was the de facto mayor as well as the town planner, the majority landowner, the developer, and the benefactor. In these early days, his Hershey Improvement Company did all the building of roads and houses. Utilities and other services were run under the umbrella of the Hershey Chocolate Company. The name of Hershey was given to the town when the public was invited to send in suggested names for the new post office that opened in 1906.

Milton Hershey believed it was important to provide quality education for his employees' families. He constructed the McKinley School in the center of town to provide a modern centralized educational system for grades one through twelve. It replaced four one-room schools located in different parts of Derry Township. The high quality of the school led other one-room schools to join the Hershey Public School. In turn, student population growth led to the school's enlargement and later its replacement by a still larger building.

Milton Hershey also encouraged the town's residents to take an active role in establishing community services. The volunteer fire company was formed in 1905, the YMCA in 1910, and the YWCA in 1911. A variety of literary and social clubs, the Hershey Band, and local baseball and basketball teams were also formed. Hershey supported the local organizations by providing meeting halls, uniforms, and equipment.

As in other model company towns, land was set aside for a park at the very beginning. Initially planned as a picnic grounds, Hershey Park developed into much more. By 1910, it had grown to include a children's playground, a band shell offering daily concerts, a swimming pool, a free zoo, a bowling alley, and amusement rides such as a miniature railway and a carousel. Although originally established for community use, the park soon became a tourist attraction, as did the chocolate factory and the town itself.

The growth and development of the town were made possible by the success of the Hershey Chocolate Company. The company was generating more profits than Milton Hershey was able to spend. Having no children of their own, the Hersheys decided to create the Hershey Industrial School, a boarding school for orphaned boys, in 1909. By that time he and his wife, Kitty, realized that they would be childless. The Hersheys sought to put their money to good use by helping needy children. The first ten boys enrolled in 1910.

In 1913, the company town took the opportunity to commemorate its accomplishments with a tenth anniversary celebration. The last weekend in May was filled with a parade, band concerts, daredevil airplane flight demonstrations, and speakers who celebrated Hershey's accomplishments and looked to the future growth of the model community. Hershey seemed on the verge of a new wave of development and expansion.

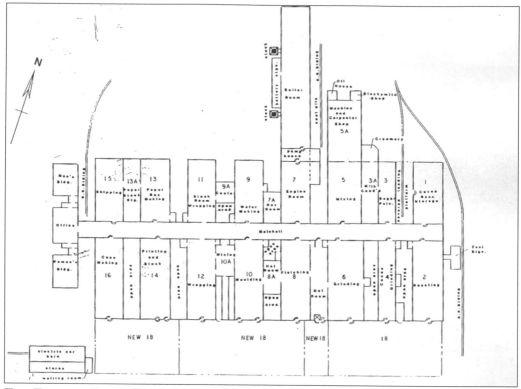

THE FACTORY FLOOR PLAN, 1905. The first factory covered 6 acres. Because of concern regarding dangers posed by stairs in the event of fire, the building was only one story high. It was designed and built to manufacture chocolate in the most efficient way possible. Raw materials—cocoa beans, milk, and sugar—were delivered at one end of the factory and were processed, emerging at the other end as finished products ready for market.

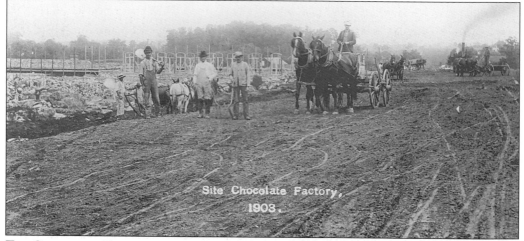

THE CHOCOLATE FACTORY CONSTRUCTION, 1903. The factory was built on a limestone bed, and much of the building material was quarried on site. Construction proceeded quickly. The slate roofs were on before that first winter to allow the carpenters, plumbers, and machinists to work under cover. By the summer of 1904, the chocolate company office was completed, and in December the factory building was finished.

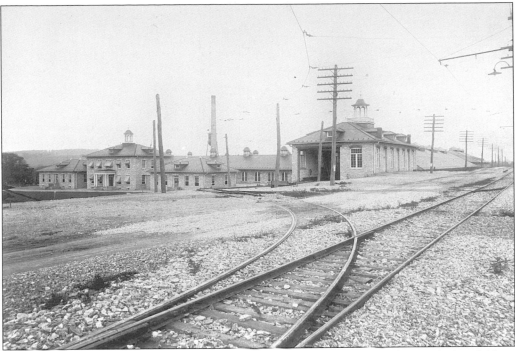

THE HERSHEY CHOCOLATE FACTORY AND CAR BARN, 1905. Several years before Milton Hershey began building his trolley network, Lebanon & Annville Street Railway cars were running between Lebanon and Palmyra. Hershey's transit system first connected with Palmyra and next with Hummelstown to provide a link to Harrisburg. As the chocolate factory's need for milk increased, the trolley system expanded to reach new milk stations near Campbelltown, Mount Joy, and Elizabethtown.

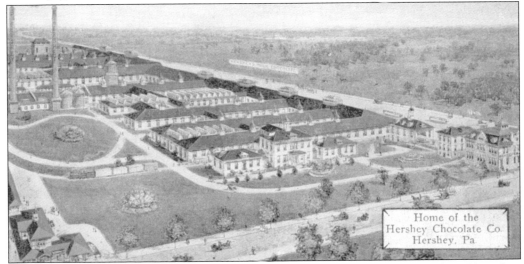

A CHOCOLATE BAR POSTCARD, C. 1910. Between 1909 and 1918, the Hershey Chocolate Company inserted specially sized postcards, such as this one, in standard-sized milk chocolate bars to promote the company and the town. The postcards showed scenes of factory operations, dairy farms that illustrated milk chocolate's wholesome ingredients, and attractive views of Milton Hershey's model town.

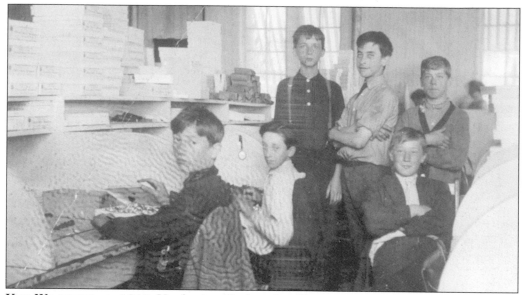

KISS WRAPPING, C. 1910. Hershey's milk chocolate Kisses were introduced in 1907. At first, the candies were hand wrapped in silver foil. An imprinted piece of tissue was included with each Kiss to identify it as a genuine Hershey's product. Since the buyer could not see that identification until after he unwrapped the Kiss, it encouraged many inferior imitations. In 1921, Hershey developed mechanical wrapping machines that inserted a visible trademark plume. The Kiss plume assured consumers that they were buying the genuine product before they took a single bite.

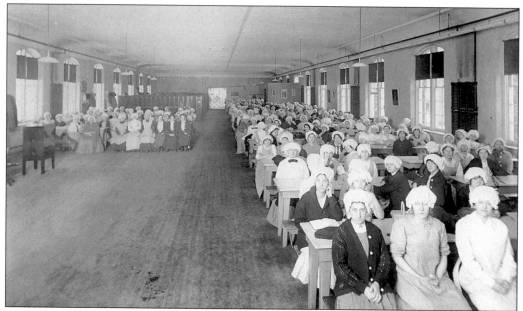

THE WOMEN'S LUNCHROOM, C. 1915. The Hershey Chocolate Company prided itself on its provisions for workers. Early publications celebrated the "welfare" provisions for workers: rooms set aside for male and female workers to eat lunch and relax during the one-hour noontime break. Each worker was also provided with a locker for personal belongings. In pleasant weather, employees often spent the lunch hour visiting nearby Hershey Park.

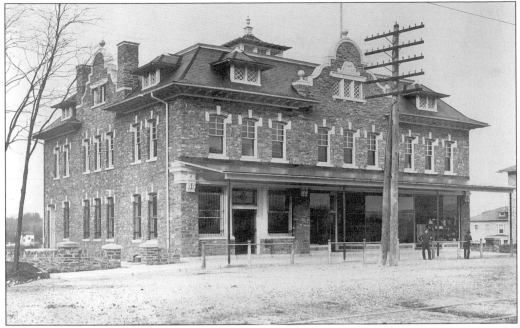

THE COCOA HOUSE, C. 1909. The first building erected in town after the factory was the Cocoa House. Initially, it served as the town center, containing a store, a bank, a post office, boarding rooms for men, and a lunchroom. As the town grew and services moved into new facilities, the Cocoa House was enlarged and remodeled to serve as the home for the YMCA.

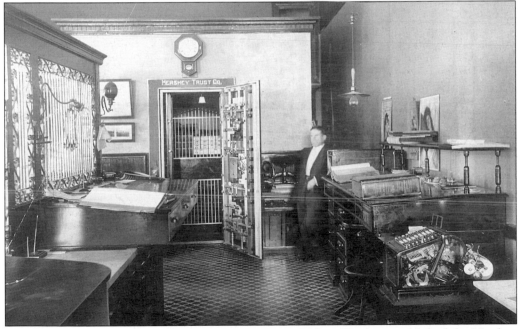

THE HERSHEY TRUST COMPANY INTERIOR, C. 1910. Milton Hershey established the Hershey Trust Company to serve as the community's bank. In addition to handling Hershey business payrolls, the bank offered savings accounts, mortgages, and commercial and private loans. It began operation on June 15, 1905, in offices located in the Cocoa House.

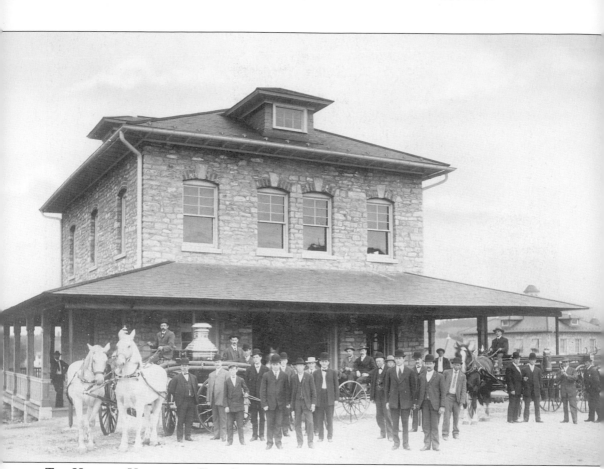

The Hershey Volunteer Fire Company, c. 1910. Formed in 1905, the Hershey Volunteer Fire Company was the first service organization in Hershey. When the charter was granted in 1907, it listed 73 men, including Milton Hershey. He personally supported the organization by providing a building and purchasing fire trucks and equipment, including the button steam pumper pictured. Originally, the fire company was housed in an East Chocolate Avenue building next to the factory.

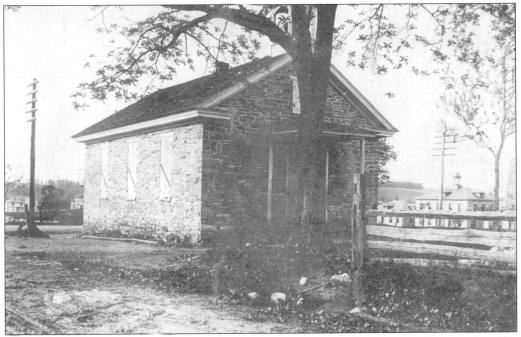

THE GREINER SCHOOL, C. 1904. The Greiner School, built c. 1865, was the second public schoolhouse constructed in Derry Township. It was located on the corner of Chocolate and Cocoa Avenues and was torn down in 1905 to make way for a new four-room school building. Note the chocolate factory visible in the background. (Courtesy of Neil Fasnacht.)

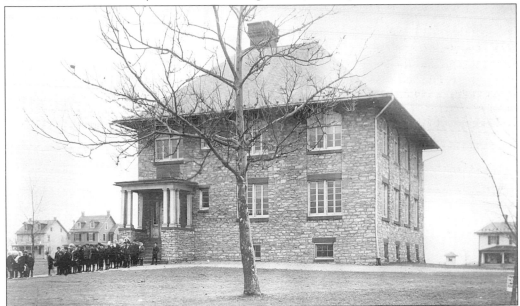

THE MCKINLEY SCHOOL, 1908. Milton Hershey thought it was very important to provide the community's children with a quality public education. In 1906, he donated a new four-room building, the McKinley School, that replaced four one-room schools located in different parts of Derry Township. It provided a modern, centralized educational system for grades one through twelve.

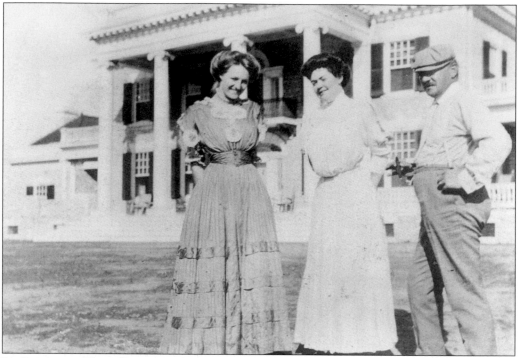

IN FRONT OF HIGH POINT, C. 1908. High Point, while a gracious and comfortable home, was relatively modest for individuals of the Hersheys' financial means. The construction, furnishings, and landscaping of High Point may have cost as much as $100,000. In comparison, George Vanderbilt spent an estimated $10 million for his 400-room mansion Biltmore, situated on 125,000 acres in Asheville, North Carolina. Pictured, from left to right, are Louise Baird (friend), Catherine Hershey, and Milton Hershey.

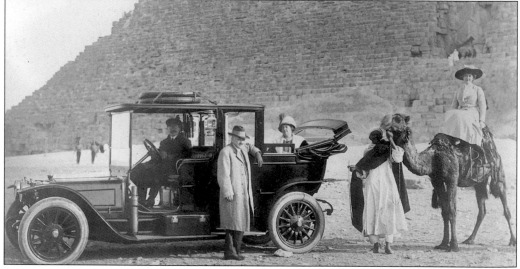

VISITING THE PYRAMIDS OF EGYPT, 1913. Following the upper-class fashion of the day, the Hersheys traveled extensively in the United States and abroad. Much of their travel was devoted to visiting health spas, seeking a cure for Catherine Hershey's progressive poor health. Pictured, from left to right, are Milton Hershey, Catherine Hershey, and cousin Ruth Hershey.

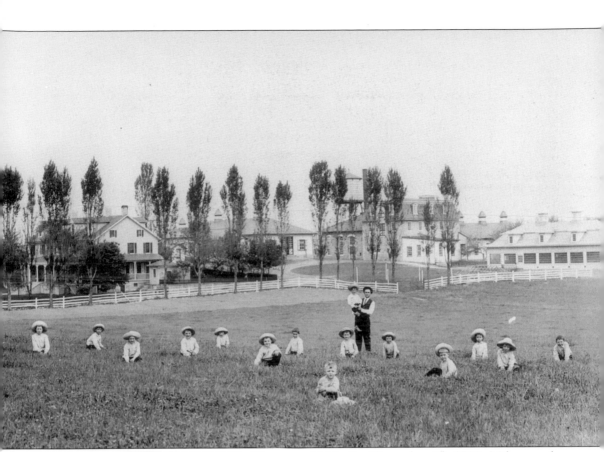

THE HERSHEY INDUSTRIAL SCHOOL BOYS, C. 1911. On November 15, 1909, Milton and Catherine Hershey signed a deed of trust establishing the Hershey Industrial School. Milton Hershey's birthplace, the Homestead, was chosen as the first site for the new school for orphan boys. The first ten boys were enrolled in 1910, with the Homestead serving as both home and classroom. The original school trust was endowed with 486 acres of farmland and the income derived from it. The income was not adequate, and during the early years, Milton Hershey paid for many of the school's expenses out of his own pocket. He and his wife were fond of the boys and thought of them as family. Proud of the school, the Hersheys often visited the boys and participated in their activities. The school grew quickly; by 1915, over 50 boys were enrolled.

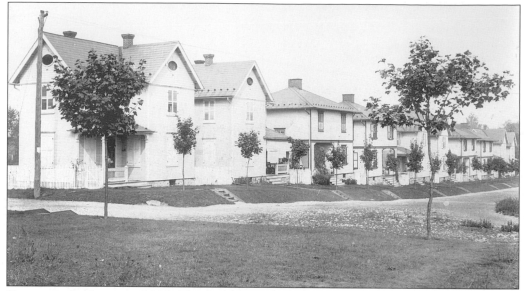

TRINIDAD AVENUE, C. 1910. The first homes built for Hershey workers were located north of the factory, adjacent to the town of Derry Church. While they were solid, well-built homes, only two designs were used, and Milton Hershey was unhappy with their sameness. He did not want his town to look like a factory town, so he instructed future builders to construct homes with a variety of designs to create visual interest.

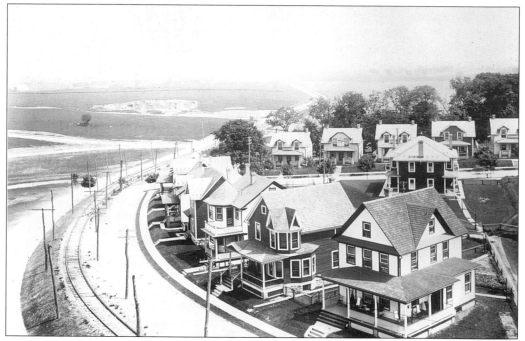

JAVA AVENUE, LOOKING SOUTH, C. 1915. Hershey-built homes were available for rent and sale by the Hershey Improvement Company. Through local newspaper advertisements, Hershey encouraged people to buy lots and build their own homes. From the start, there was a great demand for housing. However, Milton Hershey wanted to give workers a choice in where they lived. He therefore developed the trolley system linking the community with surrounding towns.

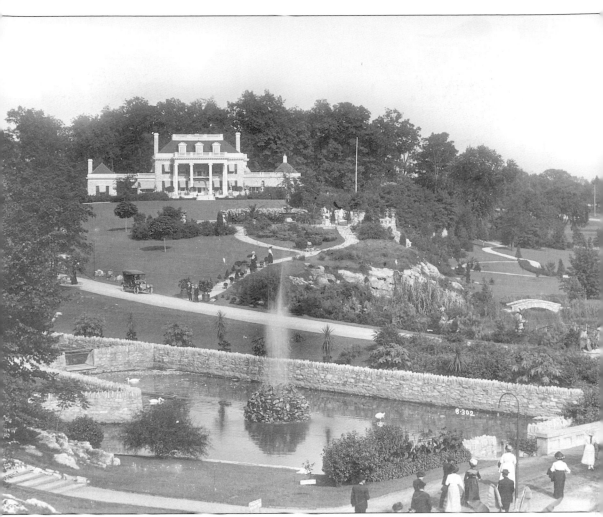

HIGH POINT MANSION, 1913. The Hersheys chose a hill adjacent to the chocolate factory for the site of their new home. From the front porch, they looked out on the factory. Catherine Hershey personally supervised the landscaping of their home, incorporating many flower beds, statuary, and fountains. From the beginning, High Point's grounds were open to visitors.

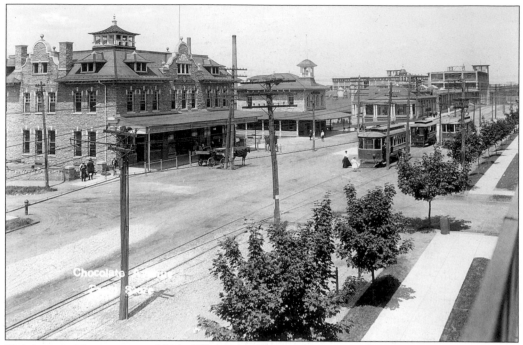

CHOCOLATE AVENUE, C. 1912. When the community was laid out, its main streets were christened Chocolate and Cocoa Avenues. Milton Hershey celebrated the town's focus on chocolate by naming other streets for cocoa-growing regions in the world: Java, Trinidad, Ceylon, Granada, Caracas, Areba, and Para.

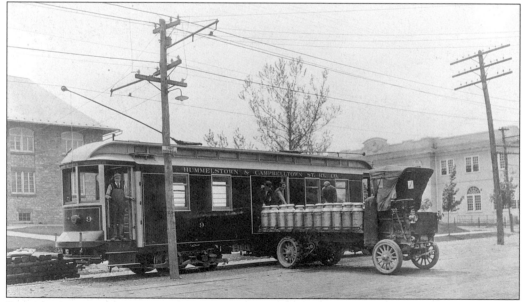

DELIVERING MILK TO THE FACTORY, C. 1915. Fresh milk is critical to the production of Hershey's milk chocolate. Milton Hershey constructed an extensive trolley system to link dairy farms and milk stations to the factory. Each day, specially designed trolley cars picked up milk cans full of fresh milk and delivered them to the factory. The milk trolleys operated until the service was discontinued in 1946.

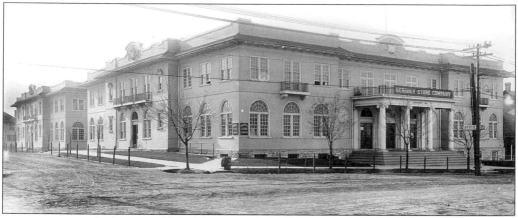

THE HERSHEY STORE COMPANY, C. 1912. Although a general store had operated in the Cocoa House since 1907, a new department store was built in 1910. The immediate success of the store resulted in the construction of a large addition the following year. The complete department store sold everything, including dry goods, groceries, ready-to-wear clothing for all ages, and home furnishings.

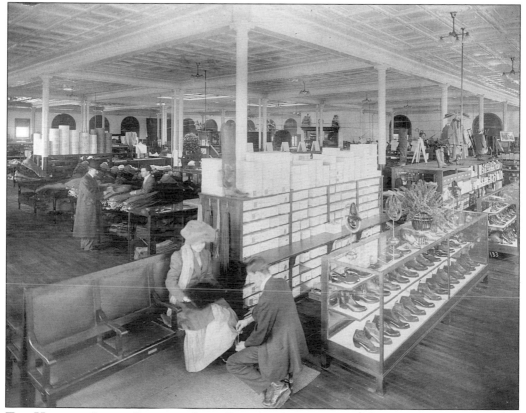

THE HERSHEY STORE COMPANY SHOE DEPARTMENT, C. 1915. The department store prided itself on the quality and variety of its merchandise. The store ran weekly advertisements in the local paper and often had special promotions featuring band music, special giveaways, and treats. When Milton Hershey's mother visited the store, clerks were instructed to offer her the best merchandise but to charge her the lesser price.

49

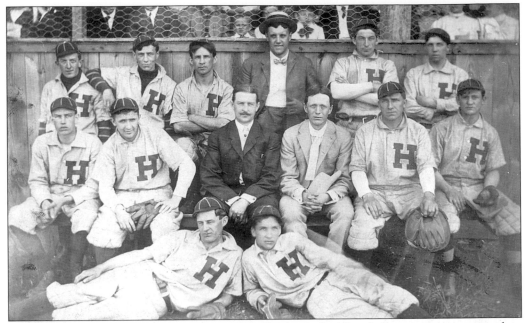

THE HERSHEY BASEBALL TEAM, C. 1910. Hershey's first baseball team was organized in 1905. Large crowds attended the games played on the Hershey Park Athletic Field. On July 4, 1912, Jim Thorpe, who attended the Carlisle Indian School, played baseball in Hershey. He was accompanied by his coach Pop Warner, a good friend of William Murrie, the president of the Hershey Chocolate Company. Their relationship led to many Native American athletes playing for Hershey.

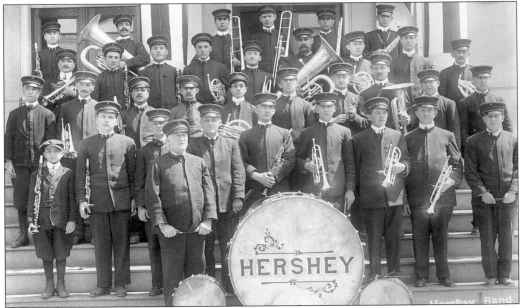

THE HERSHEY BAND, C. 1920. In September 1905, a group of factory workers met to discuss forming a brass band. Milton Hershey assisted by providing instruments and uniforms. During the early years, the band offered daily concerts at the park band shell. Often, the Hersheys came to the park in the evenings just to listen to the band.

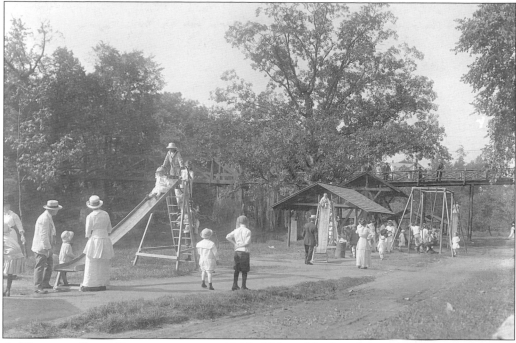

A HERSHEY PARK PLAYGROUND, C. 1915. Milton Hershey knew that opportunities for recreation were an important part of his plans for a model town. Initially, the park was planned as a green space with picnic areas, a bandstand, and children's playgrounds. Public interest in the model town soon prompted Hershey to add amusement rides.

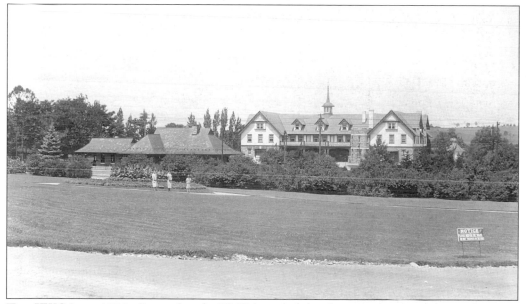

THE YWCA, C. 1913. Soon after the YMCA started, local women began to clamor for space to start a local chapter of the YWCA. Milton Hershey complied by building a limestone structure north of the railroad tracks, next to Hershey Park. The YWCA included boarding rooms for 60 women, a reading room, a game room, a large gymnasium, and a cafeteria. The YWCA also ran a kindergarten for children ages two to six.

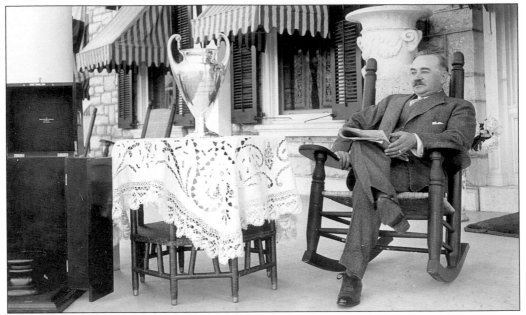

MILTON HERSHEY ON HIGH POINT'S PORCH, 1913. As part of the town's tenth anniversary celebration, employees presented Milton Hershey with a silver loving cup to commemorate the occasion. On the cup was inscribed "Presented to Milton S. Hershey as a token of affection and esteem by his employees on the occasion of the tenth anniversary of the founding of the town of Hershey."

READY FOR THE 10TH ANNIVERSARY CELEBRATION, 1913. A parade of community organizations and industries launched the anniversary celebration festivities. Four state policemen led the parade, followed by the Hershey Band, the Hershey Chocolate Company employees, various Hershey businesses, and the Bethlehem Steel Company Band, who performed in the park later that day. Milton Hershey is in the first row, fifth from the left, and Catherine Hershey is in the second row, far left.

52

Four

HERSHEY IN TRANSITION
1914–1928

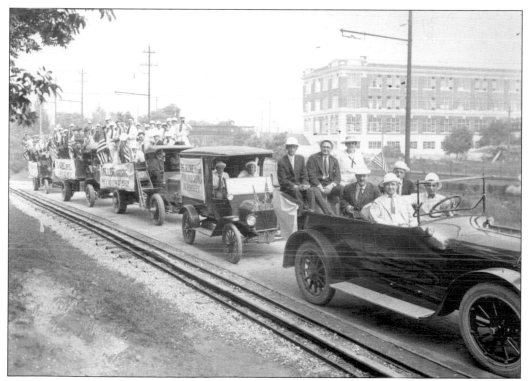

THE *GLOBE* NEWSPAPER PICNIC, HERSHEY PARK, C. 1916. During Hershey's second decade, the park expanded. New rides, such as the Wild Cat roller coaster, were added, the ballroom was enlarged, and the Hershey Zoo formally opened. Large groups were accommodated by the construction of a convention hall. These changes made Hershey an attractive destination, and more and more businesses and church groups chose Hershey Park for their summer outing.

As Hershey entered its second decade, town development gathered strength and momentum. A 1919 article in *Forbes Magazine* noted the public's interest in Hershey. The community was more than a town. It represented an ideal. The local newspaper, *Hershey's Progressive Weekly*, celebrated those ideals by writing many articles about the "Hershey Idea." The Hershey Idea meant providing residents with a clean and healthy living environment, opportunities for pleasant recreation, and honest wages.

Like other industrialists who built model towns for their workers, Milton Hershey took great pride in his community. Local newspaper advertisements encouraged people to settle in Hershey. As the town population grew, Milton Hershey provided for new schools, a new bank building, and expanded services, such as the trolley and the telephone. A new water supply system was built in 1915. It included a large dam and new filtration plant. Two new reservoirs were also built at the top of Pat's Hill, just north of town.

The model town attracted many visitors, and even more came to enjoy Hershey's growing recreational facilities. During this time, the park expanded to twice its original size. The 4,000-seat Hershey Convention Hall attracted national conventions and band leaders, such as John Philip Sousa and the Great Creatore. Hershey's Visitors Bureau opened in the Cocoa House to help visitors find their way around town. The growing number of tourists prompted the addition of new amusements to the park. The band shell was enlarged. For the 1916 season, the original Park Pavilion was remodeled as a café. The zoo also officially opened that year.

Milton Hershey had big plans for his model town. In the fall of 1914, the *Hershey Press* announced that a large community building, with meeting rooms, a gymnasium, an indoor swimming pool, and a 2,000-seat theater would be built the following year. However, future events delayed groundbreaking.

Catherine Hershey had suffered for many years from a progressive illness. By the end of 1914, she was almost completely paralyzed. Her death in 1915, combined with the onset of World War I, redirected Milton Hershey's efforts and interests for several years.

During the winter of 1916, Hershey and his mother traveled south, first to New Orleans and then on to Cuba, a popular cold-weather destination. Cuba was known for its balmy climate, friendly people, and extensive sugar plantations. Hershey's visit inspired a plan to purchase sugar plantations and build sugar mills to supply sugar for his growing chocolate business. True to his style, Milton Hershey built not only sugar mills but also a model town, Central Hershey, for his Cuban workers.

As the clouds of World War I gathered back home in Pennsylvania, the community joined together to support the war effort, forming Red Cross committees, planting war gardens, and buying war bonds. At the factory, women assumed traditional male jobs as men left to join the war. The Hershey Chocolate Company also supported the war effort, filling a government purchase order to provide a half-pound milk chocolate bar to every American soldier for Christmas of 1918.

The community was not immune to the influenza epidemic that swept the United States during the final year of the war. On Pat's Hill, an isolation house opened, and a nurse was hired to oversee operations. Following the war, Hershey expanded regular medical services with the introduction of a well-baby clinic. In 1924, Hershey Hospital opened, featuring a ten-bed facility complete with X-ray and operating rooms.

In the midst of war, Milton Hershey focused his attention on providing for his school. In 1918, he quietly transferred the bulk of his wealth, his ownership of the Hershey Chocolate Company, and other community businesses, to the Hershey Trust Company, in trust for the Hershey Industrial School. While his will had provided for the eventual transfer of his estate, the death of his wife prompted him to make the gift while he was still alive. There was no official announcement of the gift, and news of it did not become public until 1923.

As the war clouds cleared, Hershey faced another crisis. Increased consumer demand for chocolate had accompanied growing sugar shortages and rapidly increasing prices during the war years. Unfortunately, Hershey's Cuban sugar mills were still under construction and were

not ready to produce enough sugar for the chocolate factory. Milton Hershey began buying sugar futures at inflated prices to ensure an adequate supply of this essential ingredient. After the war, the sugar market collapsed, and the Hershey Chocolate Company lost more than $1 million in 1920. The company was mortgaged. The mortgage holding bank sent a representative to oversee the management of the company. Milton Hershey viewed this crisis as a challenge. He turned to his workers, and the town rallied behind him to work to free the company from its obligation to the mortgage holder by June 1922.

During the 1920s, Hershey came into its own as a tourist destination. It was during this time that Hershey claimed the title "Pennsylvania's Summer Playground." Special picnic trains were arranged from Harrisburg and Lancaster. Several new rides were added to the park, beginning with the town's first roller coaster, donated by Milton Hershey in honor of the town's 20th anniversary. The Hershey Park Ballroom began booking national dance bands.

Town services grew and expanded. The Hershey Department Store moved to the Hershey Press Building, vacated when printing moved into space in the factory. The Hershey Inn remodeled the old department store and expanded its operations to market to a growing tourist trade. The dominance of Hershey-owned businesses created a unique look to the downtown. The department store sold everything from groceries to furniture and also contained a drugstore and a soda fountain, all under one roof. While other privately owned service businesses operated in town, they were located on side streets, away from Chocolate Avenue, the main street.

To keep up with the town's growing population, Milton Hershey donated two more school buildings. In 1914, the M.S. Hershey Consolidated School was built to hold 800 students in grades one through twelve. The rapid increase of students wanting to attend Hershey public schools next led to the construction of the Hershey Junior-Senior High School in 1925.

Buildings were reused and recycled whenever possible. Following the construction of the new M.S. Hershey Consolidated School, the original school building, the McKinley School, was renovated to serve as the town's first community building. This building housed the Central Theater, the public library, the Hershey Employment Bureau, and the local Red Cross chapter.

Before the Hershey Chocolate Company's financial difficulties in the early 1920s, Milton Hershey had privately held the company and could spend money in any way he chose. After the sugar crisis and the need for outside financing, he lost his total control. In an effort to resolve this conflict and to liquidate the remaining debt, the Hershey Chocolate Company was reorganized in 1927. Three corporations were created. The chocolate business was renamed the Hershey Chocolate Corporation. All the non-chocolate business was separated into a new privately held concern, Hershey Estates. Milton Hershey's Cuban interests were organized as the Hershey Corporation. Stock in the Hershey Chocolate Corporation was offered to the public, with majority ownership held by the Hershey School Trust. This new arrangement enabled Milton Hershey to spend money on town improvements without questions from his investors.

The late 1920s was an era of high finance and huge mergers. In 1929, Milton Hershey was offered the opportunity to merge his chocolate company with two other food companies: the Colgate-Palmolive-Peet Corporation and the Kraft Phoenix Cheese Corporation. The merger never took place because of the stock market crash. While Hershey Chocolate would have remained a separate company, the financial beneficiary of the proposed merger would have been the orphan school. In later years, Milton Hershey himself wondered what the impact would have been on his town. Would Milton Hershey have been free to invest so heavily in his community during the Great Depression?

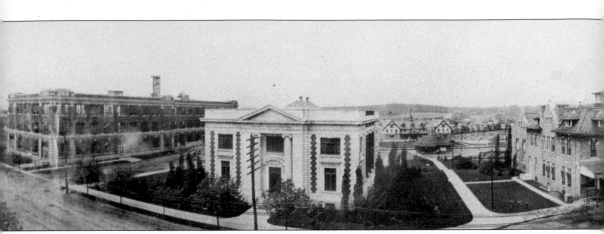

CHOCOLATE AVENUE, C. 1916–1920. Milton Hershey was a man of few words and left little in writing. A biographer wrote, "The town of Hershey was the fullest and frankest portrait of the man. In it we see evidence of his business acumen, his liberal views on religion, his regrets for his own lost schooling, his love of beauty, his humanitarianism, and especially his compassion for children." As the model town entered its second decade, it was rapidly maturing

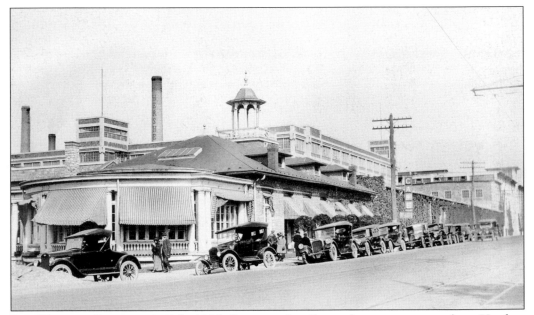

THE HERSHEY CAFE, C. 1915. In 1910, the original trolley car barn was renovated as a Hershey employee dining room. Hershey's growing popularity as a tourist destination prompted the need for a full-service restaurant, and the cafe was opened to the general public in 1911. The cafe operated until the mid-1920s, when it was closed and remodeled to provide office space for the Hershey Chocolate Sales Department.

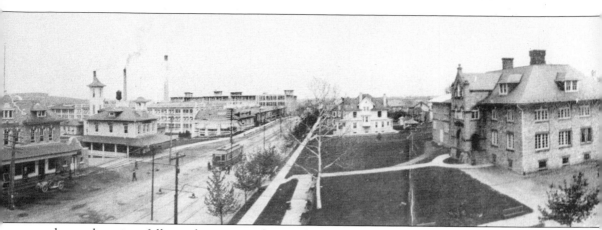

and was boasting full employment, substantial buildings, extensive community services, abundant recreational opportunities, tree-lined residential streets, and superior educational facilities. Trolleys and the railroad connected the community to surrounding towns and brought thousands of visitors to the model town each day.

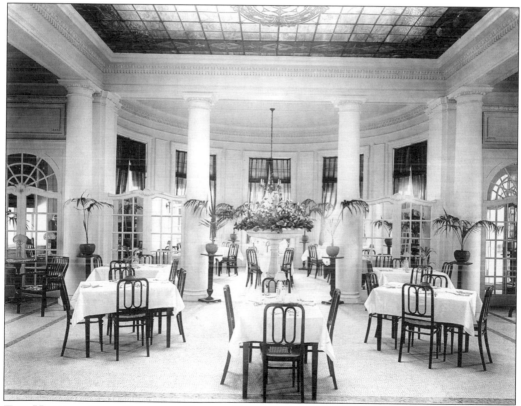

THE HERSHEY CAFE ROTUNDA DINING ROOM, C. 1916. The elegant Hershey Cafe offered two dining rooms. The main dining room seated 300 and was a popular site for banquets. The restaurant featured a solarium and mosaic tile floors. Its a la carte menu was popular with automobile travelers and other visitors to Hershey.

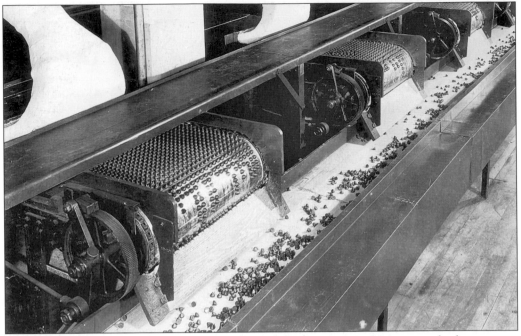

KISSES COMING OUT OF THE COOLING TUNNEL, C. 1925. To keep up with the growing demand for Hershey chocolate, the factory continuously expanded from 1909 through the 1920s. Sales grew from $8.5 million in 1914 to $38 million in 1928. During this period, several new products were introduced, including Hershey's Chewing Gum, Mr. Goodbar, Hershey's Syrup, and Hershey's chocolate chips.

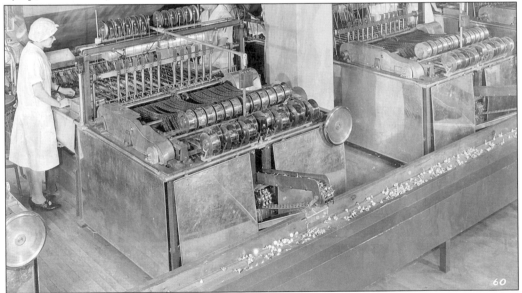

KISS WRAPPING, C. 1930. The Hershey Chocolate Company trademarked the basic shape, size, and configuration of Kisses, with their foil wrap, in 1923. During the company's early years, many items similar to Kisses were also produced. Silverpoints, Silver Tops, and Liberty Bells were made concurrently with the Kiss. Each of these other items had a relatively short life span, but Kisses remained one of Hershey's flagship products.

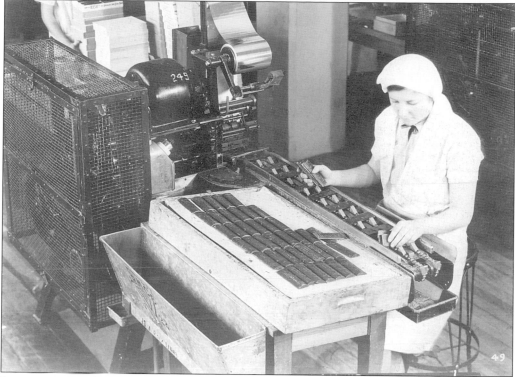

LOADING THE ALMOND BAR WRAPPING MACHINE, C. 1925. At first, all of Hershey's confectionery products were wrapped by hand. The company soon began working toward automating production. One of the first steps was to develop mechanical wrapping machines for bars and Kisses.

A POSTCARD: HERSHEY RAILROAD STATION, C. 1910–1915. Milk chocolate bar postcard inserts were illustrated with views of the factory and the town. These views celebrated the process of making milk chocolate and the town built on chocolate. The railroad was critical to the company's success, delivering raw ingredients and shipping finished goods to customers throughout the United States.

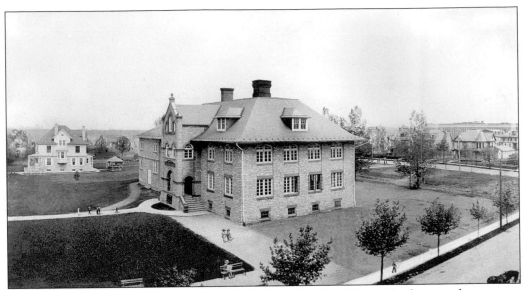

THE MCKINLEY BUILDING, C. 1915. Whenever possible, Milton Hershey sought to reuse buildings. After the public school moved to the M.S. Hershey Consolidated School, the McKinley School was refurbished as the first community center. In a similar manner, the home of his mother, located next to the school, was remodeled after she died to serve as nurses' housing for the new Hershey Hospital, located in an adjacent Chocolate Avenue house.

THE HERSHEY MEN'S CLUB, C. 1915. Hershey organized a chapter of the YMCA in 1910. Housed in the Cocoa House, it was generously supported by Milton Hershey. It operated boarding rooms for 55 men and offered a wide range of programs for men and boys. However, by 1913, the men felt that the national organization was too restrictive and started their own men's club.

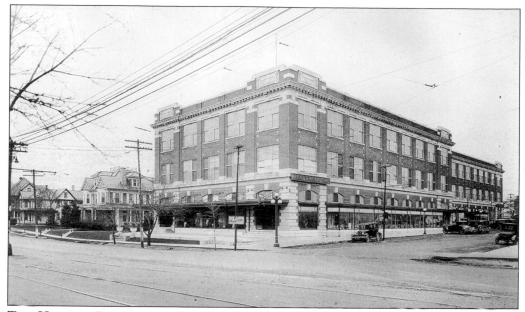

THE HERSHEY DEPARTMENT STORE, 1927. By 1920, the store had outgrown its original location. It moved across the street into this building, originally constructed to house Hershey's printing business. The store prided itself on the breadth and quality of its merchandise, claiming that customers could buy anything from a toothpick to an automobile. It boasted a complete grocery store with a greengrocer and fresh meats prepared by the Hershey Abattoir.

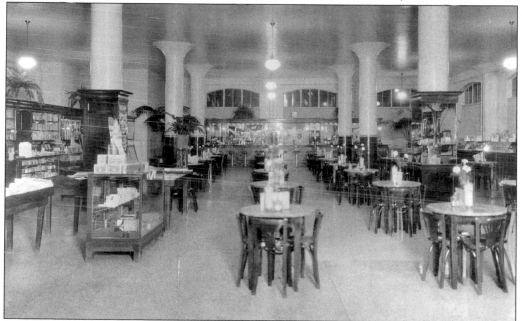

THE HERSHEY DEPARTMENT STORE SODA FOUNTAIN, C. 1925. Shortly after the Hershey Department Store opened, Milton Hershey proposed that it be operated as a cooperative enterprise. Women in the community were suspicious of the offer and refused to participate. By 1925, the store operated 21 different departments. The soda fountain was a favorite destination for many residents and visitors.

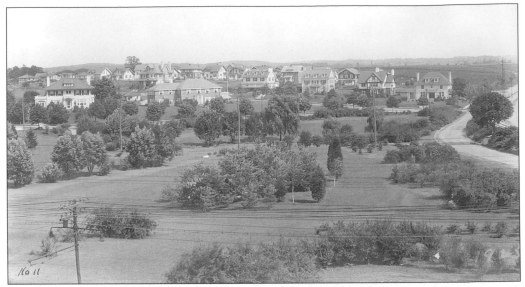

THE EAST END, HERSHEY, C. 1920. The east end of town had some of the community's most gracious homes. The houses along East Chocolate Avenue were built and occupied by Milton Hershey's top executives. Farther south, homes were built for many of Hershey's middle managers. The large open area in the foreground of the photograph is a flood plain.

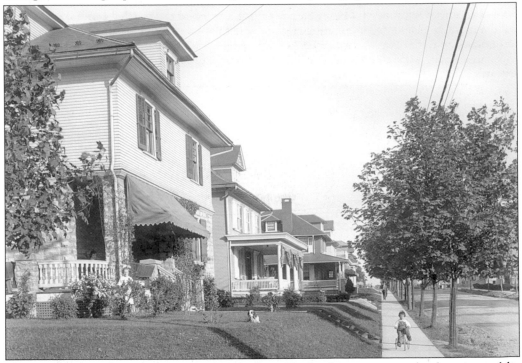

COCOA AVENUE RESIDENCES, C. 1920. Milton Hershey's attention to landscaping public spaces influenced local home owners. Residents took pride in their homes, landscaping their yards and grooming their lawns. Hershey's reputation as a model town brought more and more visitors who came to enjoy the park, to tour the factory, and to admire the town's broad, tree-lined streets, comfortable homes, and numerous services.

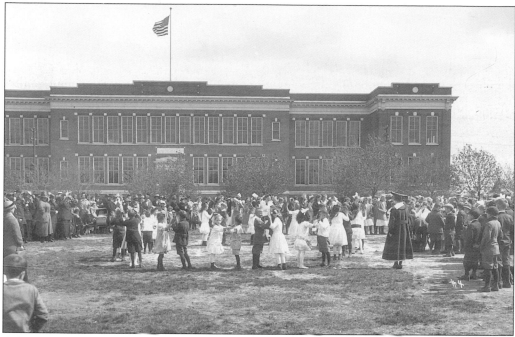

A May Dance, the M.S. Hershey Consolidated School, c. 1915. When the McKinley School became overcrowded, Milton Hershey made a proposal to the school district: he would build a new school building in exchange for the deed to the old school. Although not generally recognized, the Hershey Consolidated School system was the earliest consolidated school in Pennsylvania, leading an educational trend during the early 20th century to improve the nation's public educational system.

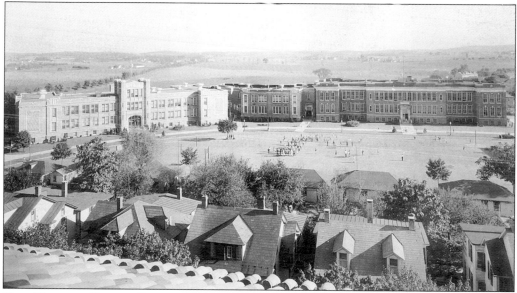

The Hershey Public Schools, 1934. Milton Hershey had an enduring commitment to providing a quality education to his community's children. As the student population grew, he built another new school building in 1925. His belief in the value of learning a trade eventually led to the 1930 addition of the Hershey Vocational School.

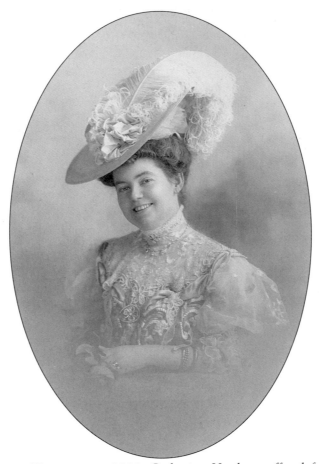

CATHERINE SWEENEY HERSHEY, C. 1900. Catherine Hershey suffered from a progressive illness, described as a "creeping paralysis," that eventually left her an invalid. The first signs of the sickness appeared three years after her marriage. Identified as locomotor ataxia, the precise symptoms and consequences were a mystery, and a modern equivalent is not known. When doctors basically gave up on her, Catherine Hershey turned to Christian Science in 1913 as a means of distraction, comfort, and support. Until her death in 1915, Milton Hershey thought of her as she was when he first met her: beautiful, innocent, and in need of his protection. He never remarried. He spent the next 30 years expanding his company, the town, and the Hershey Industrial School. He was very careful after he became a widower. He said, "I am very nice to little children and real old ladies, but nothing in between." Until his death, he carried his wife's picture with him everywhere he went.

MILTON HERSHEY, CENTRAL HERSHEY, CUBA, C. 1921. It is said that Milton Hershey fell in love with Cuba at first sight. On his first visit to Cuba in 1916, Hershey was excited by Cuba's immense sugar plantations. World War I had reduced sugar supplies, essential to milk chocolate production. During this visit, he decided to purchase sugar plantations and mills to ensure adequate supplies of sugar for the factory.

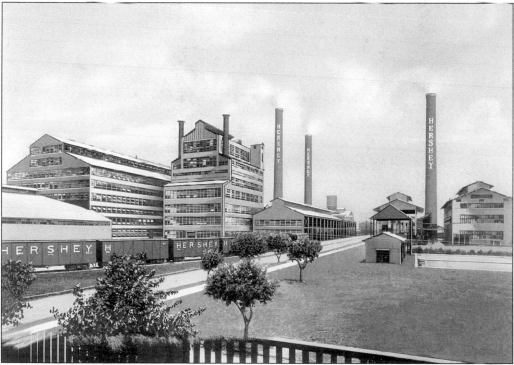

CENTRAL HERSHEY, CUBA, C. 1925. The flagship of Hershey's Cuban holdings was Central Hershey, located near Santa Cruz. The sugar mill was completed in 1918. To provide for his workers at Central Hershey, Milton Hershey constructed a town, or "batey." In addition to comfortable homes for rent, there was a general store, good health care, a free public school, and recreational facilities including a baseball diamond, a golf course, and a sport club.

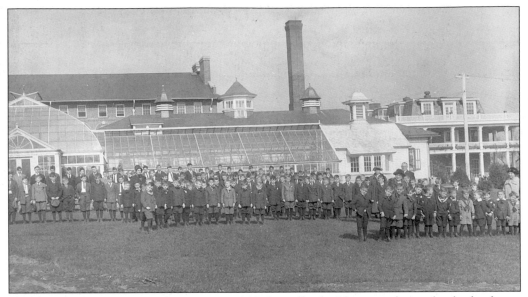

THE HERSHEY INDUSTRIAL SCHOOL, C. 1923. Initially, the Homestead served as both a home and a classroom. As the number of boys increased, the school renovated existing structures or built new buildings for classrooms, dormitories, and workshops. Student homes were supervised by women who served as housemothers. From the beginning, the school incorporated manual training and agriculture in its curriculum. Milton Hershey strongly believed in the value of learning practical skills. (Courtesy of Historical Records, Milton Hershey School.)

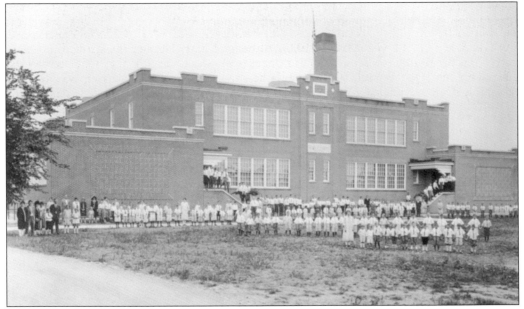

THE FANNY HERSHEY MEMORIAL BUILDING, HERSHEY INDUSTRIAL SCHOOL, 1928. In the early years of the school, most of the boys were young. As the student body expanded, the academic program became more formal and new buildings were added. A new elementary school was completed in 1928. The new building, dedicated in memory of Milton Hershey's mother, boasted not only modern classrooms but also a gymnasium and an indoor pool for the boys' use.

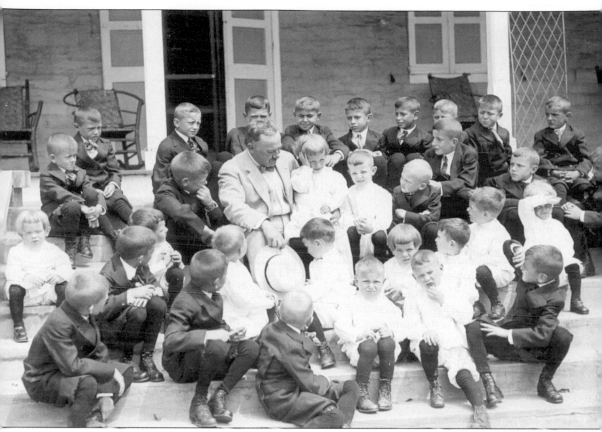

ON THE STEPS OF THE HOMESTEAD, 1923. Although Milton Hershey transferred his fortune to the Hershey Trust Company as trustee for the Hershey Industrial School in 1918, news of the gift was not made public until 1923. As might be imagined, word of the gift caused quite a stir, prompting stories in national publications, including a front page story in the *New York Times*.

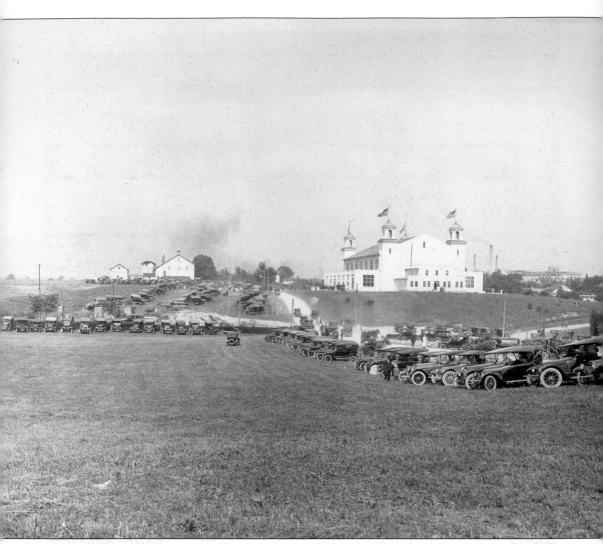

THE HERSHEY CONVENTION HALL, C. 1920. When the Church of the Brethren decided to hold its 1915 meeting in Hershey, the congregation requested permission to erect a tent on park grounds. Milton Hershey countered with an offer to build a 4,000-seat convention hall for their use. At the same time, a visitors bureau was established to coordinate a growing demand for factory tours and other services.

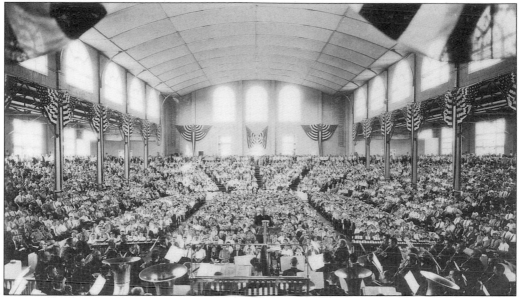

SOUSA'S BAND PERFORMS, 1925. The size and location of the Hershey Convention Hall encouraged its development as a performance hall. It hosted nationally recognized performers, including John Philip Sousa's Band, Paul Whiteman and his orchestra, the Sistine Chapel Choir, and soprano Marion Talley.

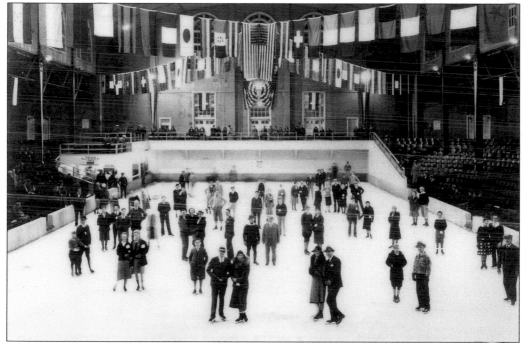

THE HERSHEY ICE PALACE, 1931. The Hershey Convention Hall was converted to an ice rink in 1926. It appeared that the community was in love with skating. In addition to ice hockey, visitors and residents flocked to skating events. The annual Hershey Skating Club Ice Carnival, first launched in 1934, attracted thousands of spectators and often completely sold out weeks in advance, with hundreds more turned away each performance night.

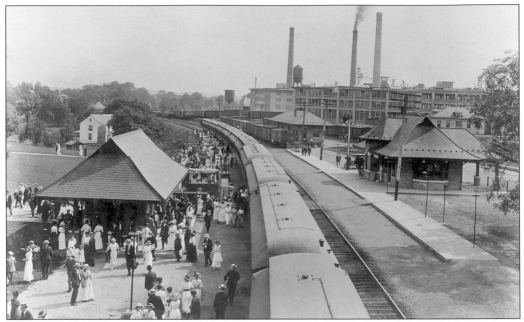

THE HERSHEY RAILROAD STATION, C. 1915. The Hershey Station was heavily used for both freight and passenger service. Five times a day, passenger trains traveling east and west stopped at Hershey. In addition, special picnic trains were often added on weekends, bringing large groups of fun-seekers to the town.

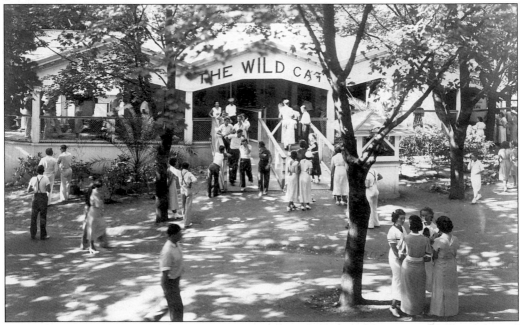

THE WILD CAT ROLLER COASTER, C. 1930S. In 1922, Milton Hershey successfully refinanced the company's debt and regained control of his chocolate business. Freed once more to spend money as he saw fit, he celebrated the town's 20th anniversary by purchasing a roller coaster for the park. Built by the Philadelphia Toboggan Company, the Wild Cat was a modern, high-speed, deep-dip coaster, which served the park well until 1945.

Five

THE GREAT DEPRESSION 1929–1938

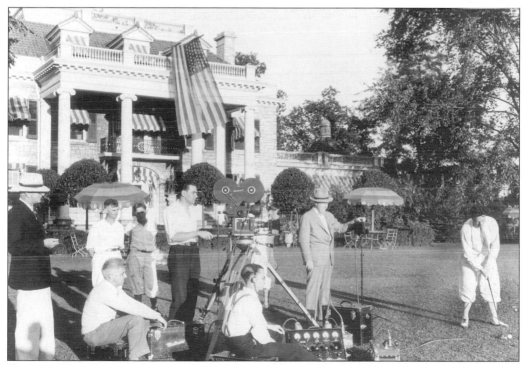

FILMING *THE GIFT OF MONTEZUMA*, 1932. Although the Hershey Chocolate Corporation did not use consumer media advertising, it did employ a variety of techniques to publicize itself. In addition to store and window displays, it published a variety of educational pamphlets that described the process of making milk chocolate and promoted the company. Building on this approach, the company produced a 48-minute educational film that described chocolate production and the model town made possible by the success of Hershey's chocolate.

The October 1929 stock market crash launched a long economic decline that grew into the worldwide Depression of the 1930s. By 1933, some 14 million Americans were unemployed, industrial production had diminished to one-third of its 1929 level, and national income had dropped by more than half. The Depression impacted not only income but also people's hopes. The Hershey community stood in sharp contrast to most of the United States during these years. While other industries retrenched and struggled to keep from shutting down, the Hershey Chocolate Corporation, thanks to its affordable and tasty product, was able to sustain sales and profits throughout the Depression. The strength of the local chocolate industry insulated other institutions in town. Unlike banks elsewhere, the Hershey National Bank remained open, securing the financial assets of its account holders.

The community of Hershey remained an enduring passion for Milton Hershey throughout his life. Hershey cared deeply for the community that he had founded and for the people who lived there and worked for him. The coming of the Depression threatened to bring economic disaster right to his doorstep. He met this challenge with his unique brand of benevolent paternalism.

Milton Hershey cared not only for his workers but also for all the residents of his community. He was an ardent supporter of public education. Many of his beliefs about education were shaped by his own experience, and he strongly believed that everyone should learn a practical skill or trade. In 1929, he decided that it was time to incorporate vocational education into the public school curriculum. This plan also benefited the Hershey Industrial School students who attended the public high school. True to Milton Hershey's style, the program was considered state-of-the-art for vocational programs. The success of the vocational education program and the growth of the boys' school prompted Hershey to build a separate junior-senior high school, with its own vocational education facilities, for the Hershey Industrial School in 1934.

As the Depression deepened, Milton Hershey undertook a major construction program, which became known as the Great Building Campaign, to bolster the local economy. During the 1930s, more than 600 men found work building many structures that later became the major tourist attractions in town. As much as these projects benefited the local economy, the campaign was not a totally altruistic endeavor. Profits from Hershey's Cuban operations provided a financial base to fund the building campaign. Milton Hershey took advantage of available skilled labor and low building costs to complete buildings that had been planned for many years. The Hershey Community Building, the Hershey Community Theatre, the Hotel Hershey, the Hershey Industrial Junior-Senior High School, the Hershey Sports Arena, and a new office building for the Hershey Chocolate Corporation were the major construction projects undertaken during these years.

In addition, many other smaller projects were initiated to provide employment to workers while developing the community. The Hershey Museum, the Hershey Rose Garden, and many new rides and attractions for Hershey Park were some of the smaller projects completed during these years. Opportunities for golf were developed with the addition of several new golf courses. In 1930, Milton Hershey started the Hershey Country Club, donating his home, High Point, for the clubhouse. He retained a small apartment on the second floor. The addition of these attractions enhanced the community's image as a center for entertainment and relaxation. By the end of the decade, the town of Hershey emerged as a nationally known tourist destination.

Hockey got its start during this time, with the Hershey Ice Palace hosting games beginning in 1931. The instant popularity of the sport resulted in the town fielding its own team the following year in the Eastern Amateur Hockey League. A sports arena was built after sports fans were repeatedly turned away due to lack of space. It appeared that the town was crazy about ice hockey. Today, the Hershey Bears have the distinction of being the oldest club in American Hockey League history.

Milton Hershey's compassion in the face of the Great Depression was not limited to providing employment for area workers. In 1935, he gave $20,000 to each of the five community churches to provide relief from mounting debt. That same year, he also created the M.S. Hershey Foundation, endowing it with 5,000 shares of Hershey Chocolate Corporation stock. Initially,

this trust was used to defray some of the expenses of the Derry Township Public Schools. In 1938, the foundation began supporting the new Hershey Junior College. Administered by the Derry Township School District, the college offered tuition-free higher education to all Derry Township residents and employees of the Hershey corporations. Housed in the Hershey Community Building, the college maintained high academic standards and helped hundreds of Hershey residents receive a college education.

The Hershey Industrial School was also affected by the Depression. Between 1929 and 1939, enrollment rose from 242 to 1,018. To house the rapidly growing student body, the school built new student farm homes. Programs such as the farm chore program and vocational education became more established. The growth of the student body led to the construction of a new junior-senior high school for the Hershey Industrial School students.

While it has often been said that no workers in the town of Hershey lost their jobs during the Depression, everyone was affected. In 1933, the National Recovery Act (NRA), which regulated prices, wages, and working conditions, became law. The NRA mandated that the work week be limited to 40 hours and that overtime be avoided wherever possible. This change had a significant impact on chocolate workers, whose 60-hour, 70-hour, and even higher-hour work weeks had been the norm. Limiting hours resulted in the factory being able to hire additional employees, but individual paychecks shrank to a critical point. This financial hardship was a contributing factor to the labor problems the Chocolate Corporation faced later that decade.

The National Labor Relations Act, passed in 1935, was intended to encourage and regulate collective bargaining between employers and employees. That same year, the CIO labor union began to court Hershey Chocolate Corporation workers. What resulted was a bitter struggle between two disparate groups: the disgruntled workers versus the loyal workers and the farmers who supplied the factory with the daily 50,000 gallons of milk required to manufacture the chocolate. Finally, in 1937, the conflict came to a head with a sit-down strike that lasted for six days. The strike ended in violence, as the strikers were forcibly removed from the factory by dairy farmers and workers loyal to the company. The strike provided a toehold for a union presence in Hershey, although it was many years before the union was able to bargain effectively for Hershey workers.

The 1937 strike was the first sign that Milton Hershey and his small group of trusted advisers might not be able to maintain their overriding influence on the town and its inhabitants into the future. However, for the present, life in Hershey settled down once more along the lines that had been mapped out by its founder.

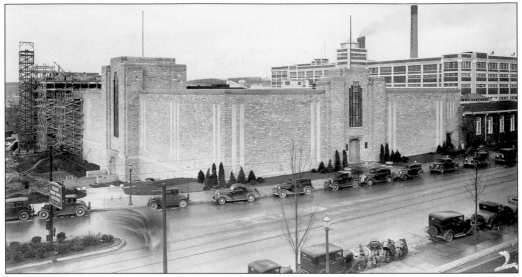

CONSTRUCTING A NEW OFFICE BUILDING FOR THE CHOCOLATE CORPORATION, 1933.
When the Hershey Chocolate Corporation needed larger quarters, initial plans outlined a conventional office building. While the foundation for that structure was being dug, the idea of a windowless air-conditioned office building was presented to Milton Hershey. Intrigued, Hershey asked builder D. Paul Witmer to construct such a building. Witmer, without stopping construction, quickly drew up new plans and built the new design.

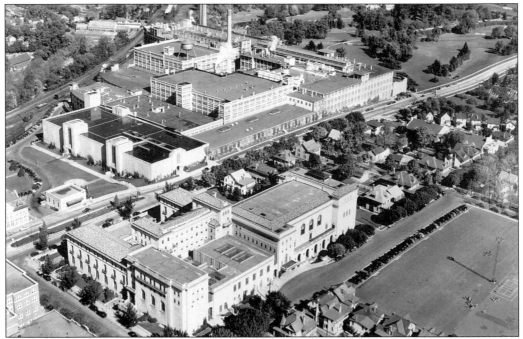

AN AERIAL VIEW, C. 1945–1950. Milton Hershey took advantage of depressed prices and the available labor force of the 1930s to activate several long-delayed construction projects. These projects included the Hershey Community Building (pictured in foreground), originally planned for construction in 1915, and the Hotel Hershey, which had been planned as early as 1909. The result was a small town that offered facilities unheard of for a community of its size.

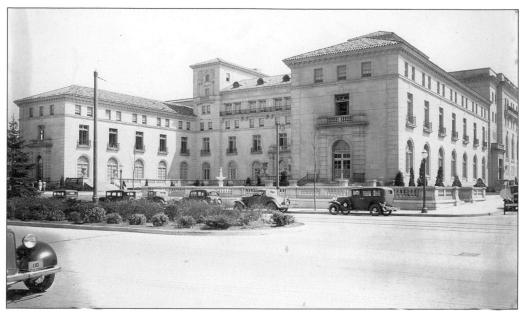

THE COMMUNITY BUILDING, C. 1934. In 1929, workers broke ground for a new community center. Originally designed by C. Emlen Urban in 1915, construction was delayed by the onset of World War I. The building included facilities for the Hershey Men's Club, the public library, the Hershey Hospital and, starting in 1938, the Hershey Junior College. The building also included the 1,904-seat Hershey Community Theatre.

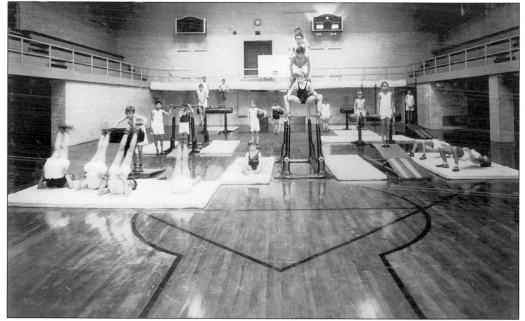

THE COMMUNITY BUILDING GYMNASIUM, C. 1935 After the Hershey Community Building was completed, the Hershey Men's Club moved across the street to its new home. There, the club had access to an indoor pool, a large gymnasium with handball and squash courts, a game room, and bowling alleys. On the third and fourth floors, the club rented dormitory rooms to single men.

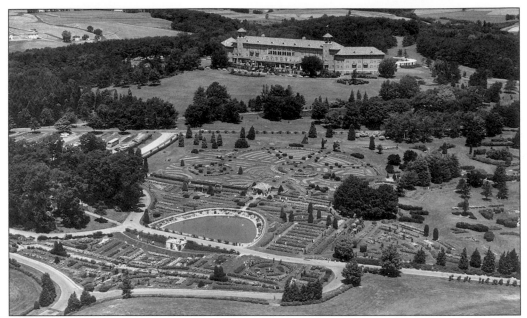

THE HERSHEY ROSE GARDEN AND THE HOTEL HERSHEY, C. 1945. In 1936, the National Rose Society asked Milton Hershey to donate $1 million for a National Rose Garden in Washington, D.C. Deciding to spend his money closer to home, Hershey directed Harry Erdman to develop a rose garden. Since then, the Hershey Rose Garden has grown from its original 3.5 acres to 21 acres of roses, annuals, perennials, shrubs, and trees.

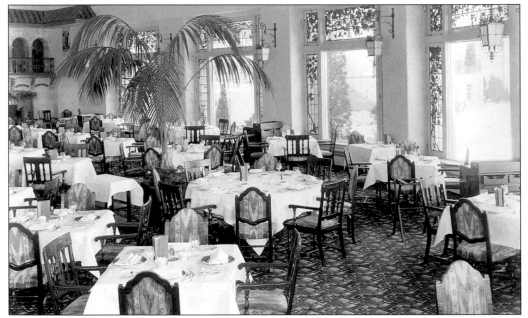

THE HOTEL HERSHEY CIRCULAR DINING ROOM, C. 1935. The dining room at the Hotel Hershey was entirely Milton Hershey's idea. He wanted a room where everyone had a good view. Initially, the room had a center column, primarily for support. Disliking the column, Hershey asked to have it removed. He said, "In some places, if you don't tip well, they put you in a corner. I don't want any corners."

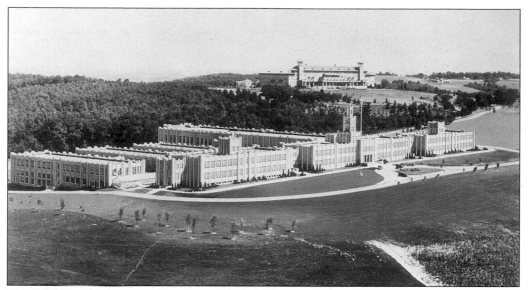

THE HERSHEY INDUSTRIAL SCHOOL SENIOR HALL, C. **1934**. Beginning in 1924, Hershey Industrial School boys attended the public high school. In 1934, a junior-senior high school was built for the Hershey Industrial School's growing student body. Boys chose from one of three courses of study: college preparatory, business, or vocational. The vocational department offered several programs, including baking and candy making, carpentry, plumbing, electricity, sheet metal, printing, and agriculture.

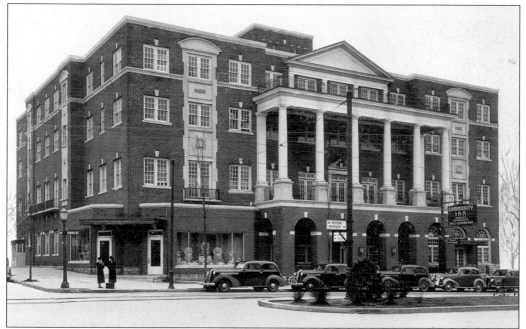

THE COMMUNITY INN, C. **1940S**. Two stories were added to the old Hershey Inn, and the entire structure was remodeled in 1936. These renovations helped the community meet the needs of its growing tourist population. The new Hershey Community Inn served as a home away from home for many performers who played at the Hershey Community Theatre and the Hershey Sports Arena. The inn's oyster bar was a popular destination for locals.

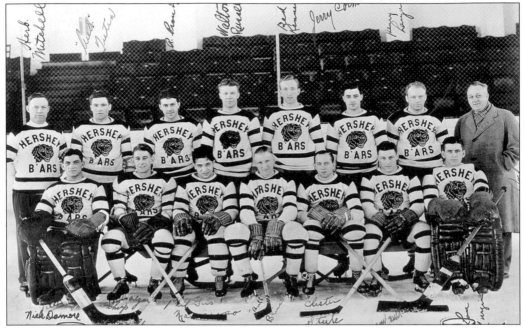

THE HERSHEY HOCKEY CLUB, 1935. Hershey's interest in hockey began in 1931, when the game was introduced at the Hershey Ice Palace. The Hershey Hockey Club was organized in 1935 and was named the Hershey B'ars. Team colors were maroon and silver, just like the famous Hershey bar. When the team later joined the American Hockey League, its name was deemed too commercial and it was modified to the Hershey Bears.

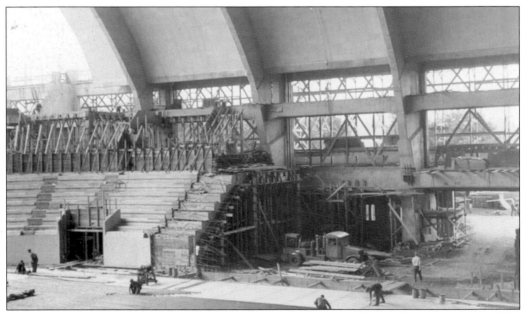

CONSTRUCTING THE HERSHEY SPORTS ARENA, 1936. The popularity of hockey prompted the construction of a new ice arena. Milton Hershey's love of new and innovative ideas led to the design and construction of a 7,200-seat reinforced concrete monolithic structure. Built without any visible means of support, the arena was the first of its kind to be built in the United States.

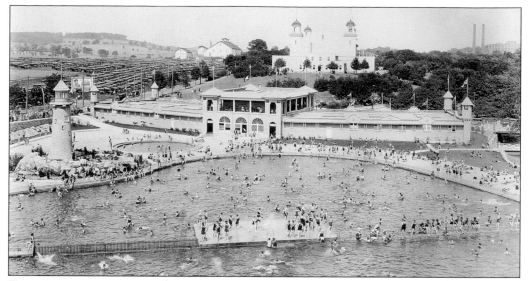

THE HERSHEY PARK SWIMMING POOL, C. 1929–1935. By the end of the 1930s, the town of Hershey had emerged as the "Summer Capital" of Pennsylvania. One of the attractions supporting this claim was Hershey's large outdoor swimming pool. First opened in 1929, the complex consisted of four pools: a baby wading pool, a large swimming pool, a diving pool, and a water toboggan pool. For an admission fee of 25¢, swimmers received pool privileges, the loan of a towel, and the use of a locker.

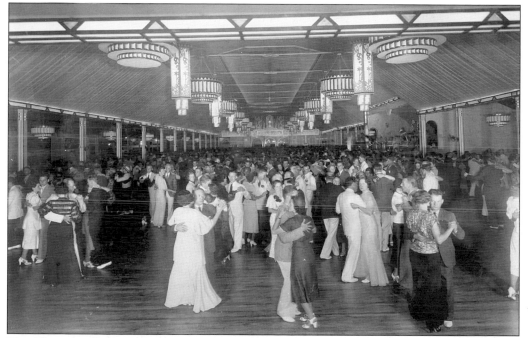

THE HERSHEY PARK BALLROOM, C. 1935. Every big band that played in the 1930s or 1940s, including Rudy Vallee, Benny Goodman, Harry James, Jimmy Dorsey, and Sammy Kaye, performed at the Hershey Park Ballroom. Anyone unable to afford the ballroom's $1.50 admission could go next door and get into the Hershey Park Pool for 25¢. On Saturday evenings, many swimmers listened to the big bands while sitting on the sandy beach.

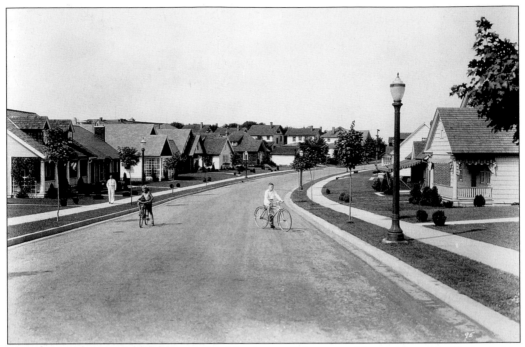

MAPLE AVENUE, C. 1935. The growth of the factory led to a need for new housing. Beginning in the mid-1920s, Hershey began to expand its residential section. The new streets were named for trees: Cedar, Maple, Elm, and Linden. Developed a block or two at a time, Hershey Estates laid water and sewer lines, put in sidewalks and streetlights, and sold lots to Hershey employees.

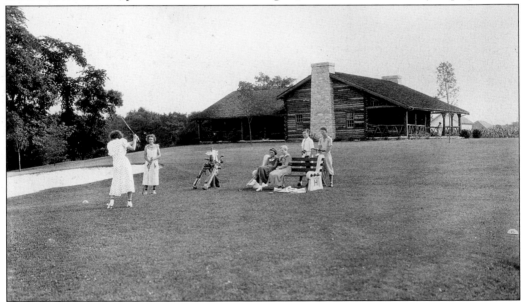

THE JUVENILE GOLF COURSE, 1934. Hershey built its first golf course, consisting of nine holes, in 1909. The community's enthusiasm for golf took off in 1929–1930, when the public Park View course and the Hershey Country Club course were developed. For the youths of the community, Milton Hershey developed a nine-hole course. Only golfers under the age of 18 could play this special course.

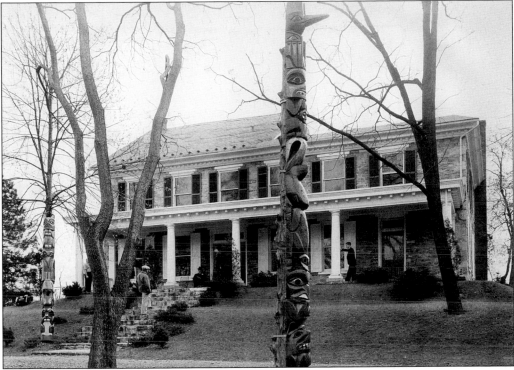

THE HERSHEY INDIAN MUSEUM, C. 1933–1935. Milton Hershey believed that cultural opportunities were important assets for a town. To start a museum, he purchased a collection of native North American artifacts assembled by John G. Worth, a knowledgeable collector of early native culture. In 1938, Milton Hershey expanded the museum by buying a collection of Pennsylvania German materials.

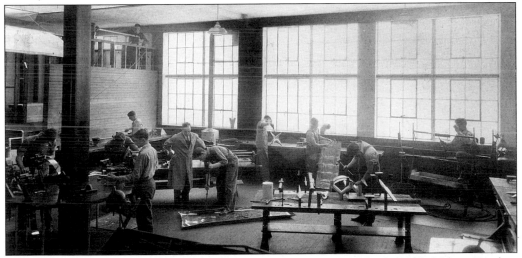

THE METAL SHOP AT THE HERSHEY VOCATIONAL SCHOOL, C. 1940. In 1929, Milton Hershey decided to start a vocational education program in the public school. Earle Markley, a noted vocational education teacher, was hired to plan and implement the program. Markley oversaw the design of the vocational school and developed a cutting-edge program. The school not only taught mechanical trades to boys but also offered a vocational program for girls.

A TESTIMONIAL DINNER, THE HARRISBURG CHAMBER OF COMMERCE, FEBRUARY 17, 1936. While Milton Hershey usually resisted efforts to honor his achievements, he relented when asked by the Harrisburg Chamber of Commerce. He was lauded by local politicians, business leaders, and state officials at the dinner held at the Penn-Harris Hotel. More than 400 business and professional men attended the dinner. (Courtesy of Historical Records, Milton Hershey School.)

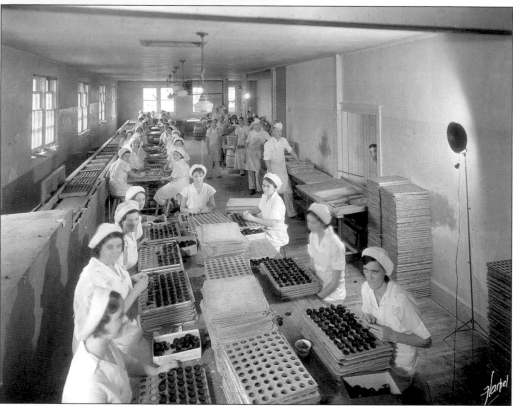

CUPPING AND HAND-DIPPING, THE H.B. REESE CANDY COMPANY, 1935. Harry Reese began making candies in the basement of his Hershey home *c.* 1923. He made a wide variety of candies, packing them in 5-pound boxes. As the business expanded, Reese built a factory on Caracas Avenue. He added peanut butter cups to the line *c.* 1928. In 1942, the H.B. Reese Candy Company discontinued making all other products to focus on the peanut butter cup.

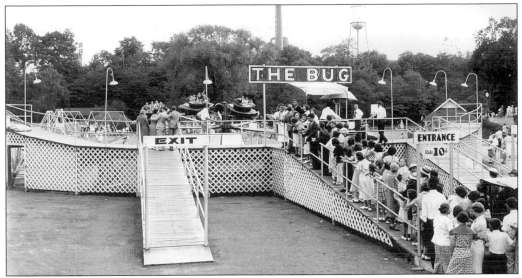

THE BUG, HERSHEY PARK, C. 1935–1940. Despite the Depression, Hershey Park continued to expand and to add new rides. Some of the top attractions added during these years were the swimming pool, the water toboggan slide, the Pretzel dark ride, the Fun House, the Custer car ride, the Whip, and the Auto Skooter. The Bug, a coasterlike ride operating on a single track around a center shaft, was added in 1932.

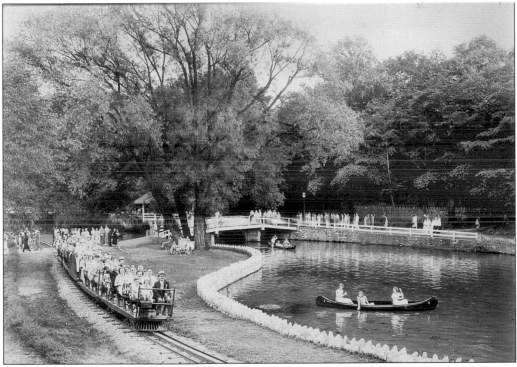

THE MINIATURE RAILROAD, HERSHEY PARK, C. 1930–1935. This narrow-gauge railway was added to the park in 1910. The train provided visitors with an easy way of reaching the far end of the park. Starting at the railroad bridge on Park Avenue, the miniature railway traveled along the edge of the park, past the ballroom, across Spring Creek, ending at the baseball field.

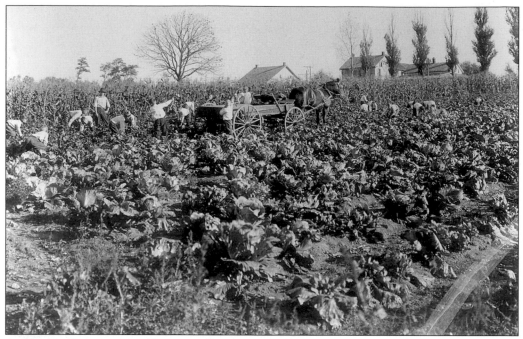

A TRUCK PATCH, THE HERSHEY INDUSTRIAL SCHOOL, C. 1930. The school's Deed of Trust instructed that the boys be trained "in agriculture, horticulture, and gardening." Milton Hershey believed a farm experience was essential for every boy. The school's truck patches introduced the boys to farming. They grew all the vegetables needed by the school and sold the excess.

BROAD ACRES FARM, THE HERSHEY INDUSTRIAL SCHOOL, C.1932–1935. During the Depression years, enrollment rose rapidly—from 242 in 1929 to 1,018 in 1939. Milton Hershey wanted the older boys to experience living on a farm. Beginning in 1929, the school built a series of student farm homes for the older boys. These boys participated in a farm chore program, assisting their housefathers in the dairy and in the fields. Note the Round Barn on the right.

THE CHOCOLATE FACTORY SIT-DOWN STRIKE, 1937. Following the passage of the 1935 National Labor Relations Act, which granted labor the right to unionize, the CIO began to court Hershey factory workers. In February 1937, Hershey Chocolate recognized the CIO. Talks broke down, however, and in April the conflict came to a head with a sit-down strike that lasted for six days.

THE CHOCOLATE WORKERS LOYALTY PARADE, 1937. The presence of an independent workers union was not universally welcomed by Hershey employees. When striking workers occupied the factory, rallies were held in the arena and thousands of workers, farmers, and residents marched in a parade to show their loyalty to Milton Hershey.

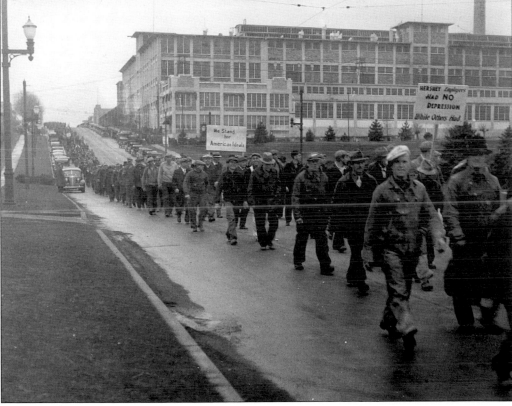

MILTON HERSHEY'S 80TH BIRTHDAY CELEBRATION, SEPTEMBER 13, 1937. Some 6,000 employees gathered in the arena to celebrate Milton Hershey's 80th birthday. A birthday cake, 3 feet high and lighted with 80 electric candles, stood in the center of the arena. Milton Hershey was serenaded by four local bands, and there was ice cream and cake for everyone. His employees gave him a gold ring engraved with the company trademark of a baby in a cocoa pod.

Six

THE WAR YEARS
1939–1945

THE ARMY-NAVY 'E' AWARD CEREMONY, AUGUST 27, 1942. The Hershey Chocolate Corporation received the Army-Navy 'E' Production Award for exceptional efforts in producing Ration 'D' bars. The award was a great morale booster. Each employee was given a pin to wear, and the factory proudly flew the U.S. Army-Navy Production Award flag. The Hershey Chocolate Corporation was one of the few companies in the country to be presented with five of these awards before the end of World War II. Pictured in front, from left to right, are Col. Paul P. Logan, Milton Hershey, former Sen. William H. Earnest, Gen. Edmund B. Gregory, William F.R. Murrie, J.J. Gallagher, Lt. Leon Levy, F.W. Pugh, and Ezra F. Hershey.

As the 1930s drew to a close, the town of Hershey entered a more peaceful and prosperous phase. Sales of chocolate products were up. Labor relations had stabilized for the time being, and workers were making more money. The new amenities instituted during the Depression made the town an unusually lively and attractive place to live. With only about 3,500 residents, most of whom were employees of Hershey Estates or the Hershey Chocolate Corporation, Hershey was still a small company town. Nevertheless, its big attractions brought tourists in growing numbers.

By 1940, the number of tourists visiting Hershey each year rose to almost 2 million. They poured in by train, trolley, bus, and increasingly by car. A tour of the factory and a day in the park continued to be the main attractions. First-run movies and touring company theater productions with nationally known stars were seen at the Hershey Community Theatre. The Hershey Sports Arena and a new 16,000 seat stadium offered professional sports entertainment. These facilities, plus four excellent golf courses, earned Hershey the title of "the biggest little town on the sports map" from the *New York Sun* in 1940. Although fees were charged for some of these attractions, many were still free. People from all walks of life, from wealthy hotel patrons to Sunday School picnic groups, came in record numbers to enjoy Hershey attractions.

Visitors came to work as well as to play. The Hershey Community Building's meeting facilities combined with the town's well-known recreational attractions made Hershey a popular location for business and professional meetings beginning in the late 1930s.

World War II was already casting a shadow over Hershey before the United States actually entered the war in December 1941. Actions and activities that lasted throughout the war years were already starting to become part of town life. Young people began enlisting in the armed forces. The Derry Township Vocational School served as a site for the National Defense Program, where unemployed men and women, both local and out of state, trained in sheet metalworking and other skills useful for producing armaments. Women joined Red Cross programs to sew and knit for war-torn Europe. School and community groups held benefits and collected money for British war relief efforts. The Hershey National Bank and the post office began selling U.S. Defense Savings Bonds and Stamps in May 1941. Town matrons supported the war effort by chaperoning bus loads of Hershey girls to dances held at nearby Fort Indiantown Gap army base. Scrap drives were inaugurated during the summer of 1941.

By the time war broke out, the Hershey Chocolate Corporation had already laid the groundwork to become a war industry. In 1937, Hershey chemists worked with the Army Quartermaster Corps to develop a survival ration bar for soldiers. Hershey produced an initial run of 100,000 Ration 'D' bars for field-testing. By the start of the war, packaging and production procedures for large quantities of the bars were close to being ready.

After the United States declared war, the pace of life in Hershey quickened. At the chocolate factory, government orders rolled in, and employees put forth a tremendous effort to meet the demand. By the summer of 1942, the factory was in full wartime production, manufacturing at least one-and-one-half times its usual output. Its efforts later earned the company the coveted Army-Navy 'E' Award for wartime production excellence. The need for workers soared just as men were leaving to join the armed services. Women, always a large percentage of the factory work force, now stepped into traditional men's jobs. Worker shortages required that both men and women work overtime, not only in Hershey but everywhere. People commonly held two or more jobs. Farmers held jobs in the factory while running their farms. To meet the need, the company recruited workers from ever farther distances.

The factory continued its huge production output throughout World War II, producing Ration 'D' and other special military ration bars in record quantities. More than a billion bars were produced by the end of the war, as well as hundreds of millions of cocoa beverage powder units. In addition, the company directed a large percentage of its standard chocolate products to military use. It was a rare treat to taste a Hershey bar on the home front. Factory production was not limited to chocolate. The machine shop filled contracts to make parts for the U.S. Navy's 40-millimeter antiaircraft guns.

The war effort affected every aspect of life. Food, gasoline, and tire rationing, combined with a scarcity of many other consumer items, called for austerity and extra planning. The war effort created new opportunities for volunteer work. Hershey residents donated untold hours organizing and carrying out the work of war-related groups, such as the Derry Township Council of Defense and the Farm Defense Program. As part of the war effort, townsfolk saved rags, metal, rubber, fat, and paper. They grew victory gardens, bought war bonds, and gave blood. They took courses in home nutrition and home nursing. Blackouts and air raid drills were regular reminders that the country was at war.

Many Hershey buildings were designated for extra or alternate uses during this period. The Hershey Sports Arena was readied to serve as an emergency evacuation site. An aircraft warning service, manned by volunteers 24 hours a day, operated first from a Hotel Hershey cupola and later from the Hershey Industrial School Senior Hall tower. The U.S. government commandeered the Hotel Hershey from November 1942 to October 1943 to serve as an internment site for French Vichy government diplomats and their families.

Although the town still attracted tourists during the war years, rationing and reduced train service made it more difficult to get to Hershey. World War II also reduced the number of traditional Hershey attractions. Factory tours were discontinued by government order for security reasons in July 1942. With employees in short supply, Hershey Park had to curtail its hours. Quality sports and entertainment groups were in short supply for the ballroom, the band shell, and the arena.

As World War II progressed, Milton Hershey's life was drawing to a close. He remained interested and involved in all aspects of the town and particularly its war effort. He retired officially in 1944; however, the men who were in charge of the Hershey entities (the Hershey Chocolate Corporation, Hershey Estates, and the Hershey Trust Company) still sought his advice, and he continued to meet regularly with them. Until his death, Milton Hershey's interest in new ideas and his concern for the well being of others remained strong. He lived to see the end of the war and died on October 13, 1945, one month after his 88th birthday. True to his priorities, his will directed that his estate be used to establish a trust fund benefiting the public school system. On the day of his funeral, the town came to a halt. Thousands honored him as he was laid to rest alongside his parents and his wife in the lovely, wooded Hershey Cemetery, overlooking the rolling Pennsylvania countryside. He was at peace. Now that his hand was no longer on the helm, what would happen to all that he had created?

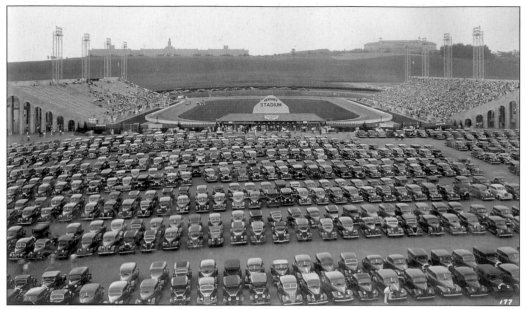

THE HERSHEY STADIUM, MAY 1939. The 16,000-seat Hershey Stadium was used for area high school and college football games as well as for professional sports entertainment and midget auto racing. For a short period during World War II, Milton Hershey had 20 trailers placed under the bleachers as housing for war workers. In the background, note the Hershey Industrial Junior-Senior High School on the left and the Hotel Hershey on the right.

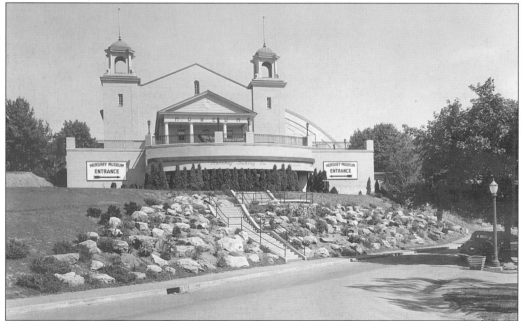

THE HERSHEY MUSEUM, C. 1940–1955. After the Hershey Sports Arena was built, the vacated Hershey Convention Hall and Ice Palace became the home of the Hershey Museum. The old museum building proved too small to accommodate the collection of Pennsylvania German artifacts that Milton Hershey bought for the museum in 1935. The museum's new location next to Hershey Park, the arena, and the stadium made it more convenient for tourists to visit.

THE CHOCOLATE FACTORY TOUR GUIDES, C. 1936–1940. Touring the chocolate factory was one of Hershey's greatest attractions through 1941. In that year alone, 69,000 people went through the factory. But from 1942 to the end of the war, it was closed to the public. The U.S. government required the closure as a safety precaution, since the factory was producing Ration 'D' bars and other products for soldiers.

MILTON HERSHEY WITH THE PGA GOLF TOURNAMENT TROPHY, 1940. The Hershey Country Club proudly hosted the 23rd Professional Golf Association championship tournament. In preparation for the event a luxurious new locker room, with space for 150 players, a pro shop, a repair shop, and a kitchen were added to the building. Playing in the tournament were 130 professional golfers from 28 states.

AUSTIN GEILING JR., ARNIE CLOTFELTER GEILING, AUSTIN GEILING SR., 1944. The Geiling men numbered among the 1,200 Derry Township men and women who served in the armed forces during World War II. Of that number, 46 died or were killed in action. Milton Hershey encouraged his employees to serve by offering a bonus of two weeks' salary to all who enlisted. (Courtesy of Austin C. Geiling Jr.)

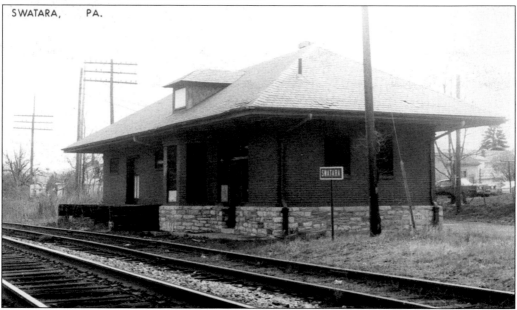

THE SWATARA RAILROAD STATION, 1976. Located just west of Hershey, the village of Swatara was the home of many families of Italian origin. A high percentage of Swatara families had members serving in the armed forces during World War II. Some 50 wives and mothers of men in service congregated at this railroad station each morning to wait for the first mail train. (Courtesy of Neil Fasnacht.)

A RED CROSS VOLUNTEERS WORK SESSION, THE HERSHEY WOMEN'S CLUB, 1943. Like their counterparts all over the United States, Hershey citizens volunteered countless hours of their time for the war effort. Red Cross volunteers took part in many activities. These included sewing, knitting, and folding surgical dressings for soldiers and war refugees, running the blood donation program, and helping families and soldiers keep in touch. (Courtesy of Derry Township Historical Society.)

A HERSHEY SPORTS ARENA HOCKEY HOUSE TEAM, 1941. Hershey offered many sports opportunities unusual for a small town. Support from Hershey Estates and local organizations made intramural hockey available at no cost to local youth. Pictured, from left to right, are the following: (front row) Dick Brunner, Jack Bernard, Bob Evans, and Irv Gonz; (back row) Dick Stover, Herb Erdman, Bud Prowell, Sterling Sechrist, and Endo Corsetti. (Courtesy of Derry Township Historical Society.)

MILTON HERSHEY, AT THE HERSHEY ZOO, 1934. Even in the last years of his life, Milton Hershey continued to visit Hershey tourist attractions regularly to see if people were enjoying them. The zoo was popular but had to be closed in 1942 due lack of personnel. Zoo buildings, like all other available spaces in Hershey, were refitted for alternative uses as part of the town's war effort.

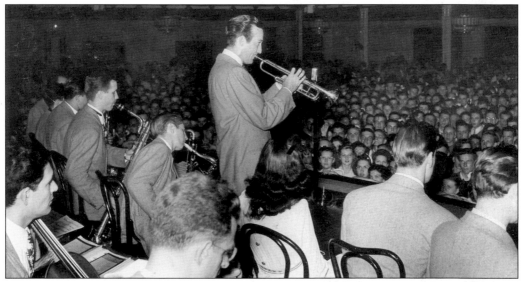

HARRY JAMES AND HIS ORCHESTRA, THE HERSHEY PARK BALLROOM, JULY 25, 1945. Fewer big-name bands toured during World War II. Park hours had to be cut due to the lack of available personnel. Nevertheless, Hershey Park remained popular, especially with servicemen and women who were given discount rates on tickets. Many in the audience came just to stand and listen to the music.

BEN HOGAN, THE HERSHEY COUNTRY CLUB, 1941. Ben Hogan was one of a series of illustrious golfers who had the position of golf pro at the Hershey Country Club. Hogan's tenure started in 1941 but was interrupted during the war years, when he joined the army air force. After the war, Hogan resumed his position until 1952, when he was succeeded by Johnny Weitzel.

Painted by PETTY
Exclusively for
*Ice-Capades
of 1945*

(25¢)

AN ICE CAPADES PROGRAM COVER, 1945. At a meeting held at the Hotel Hershey in 1940, the Arena Managers Association organized the Ice Capades. The Ice Capades performed yearly thereafter in the Hershey Sports Arena. While the arena was used regularly for sports entertainment throughout the war years, it was also designated as an evacuation center for the Harrisburg area.

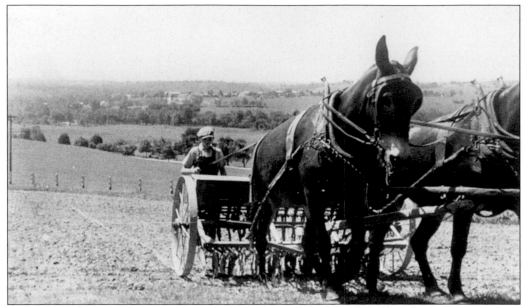

SOWING WHEAT, HERSHEY FARMS, 1941. Hershey Farms cooperated with the Farm Defense Program to increase production and produce prize crops and livestock "to aid the winning of the war." Hershey Industrial School students, such as the one shown here, continued to be an important part of the Hershey Farms work force during the war. (Courtesy of Historical Records, Milton Hershey School.)

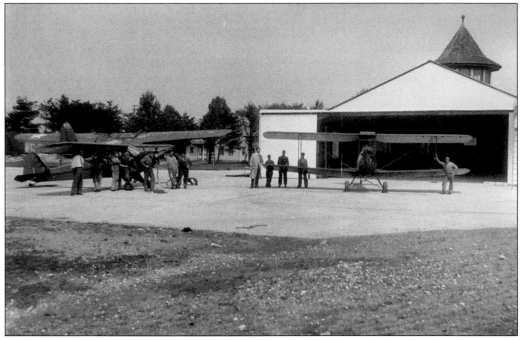

BROAD ACRES FARM, FALL OF 1944. After the Round Barn almost totally burned down in 1943, a remaining end was remodeled as an airplane hangar. Planes that Hershey Industrial School boys worked on in their airplane mechanics course were housed there. The boys used the pasture next to the hangar as a makeshift airfield to taxi the planes back and forth.

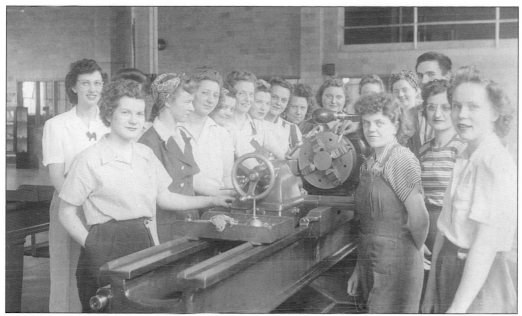

NATIONAL DEFENSE PROGRAM TRAINEES, THE HERSHEY INDUSTRIAL SCHOOL, c. 1942–1943. Industrial skills were taught to hundreds of people in Hershey, both locals and out-of-towners, throughout the World War II. Classes were held at the Derry Township Public School District's vocational school and at the Hershey Industrial School in the summer and on evenings during the school year. (Courtesy of Historical Records, Milton Hershey School.)

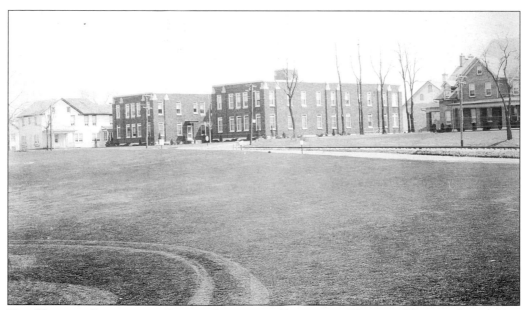

THE HERSHEY INDUSTRIAL SCHOOL INFIRMARY (LATER THE HERSHEY HOSPITAL), c. 1934. In 1941, at Milton Hershey's suggestion, the Hershey Industrial School infirmary became the third home of the town's hospital. The hospital had outgrown its two earlier facilities: the first, located in a house on East Chocolate Avenue; the second, located on the fifth floor of the Hershey Community Building.

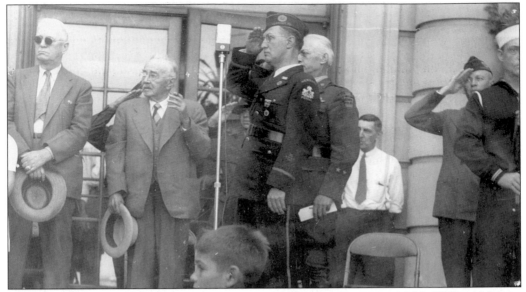

WILLIAM MURRIE AND MILTON HERSHEY AT A PATRIOTIC PARADE, 1944. William Murrie, president of Hershey Chocolate since 1908, was Milton Hershey's closest friend and confidante. The success of the Hershey Chocolate enterprise was a result of their shared efforts. By the time this picture was taken, Murrie's eyesight was starting to fail. He continued to serve as president until 1947, two years after Milton Hershey's death.

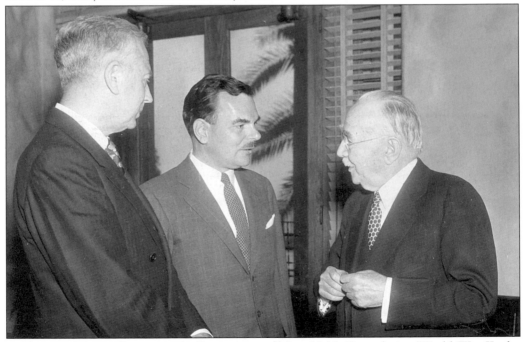

A UNITED STATES GOVERNOR'S CONFERENCE, MAY 1944. Even during World War II, the town of Hershey continued to be an attractive place for meetings and conventions. This picture was taken during the 36th Governor's Conference, which was held at the Hotel Hershey from May 28 to May 31, 1944. Pictured, from left to right, are Gov. Edward Martin of Pennsylvania, Gov. Thomas E. Dewey of New York, and Milton Hershey.

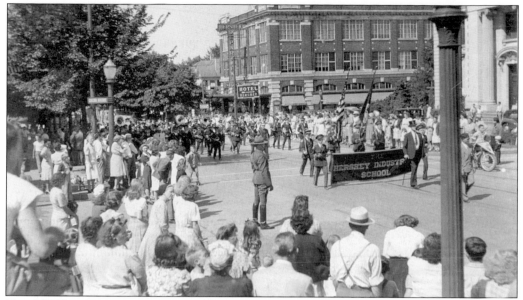

THE V-J DAY PARADE, AUGUST 1945. The citizens of Hershey celebrated the end of World War II with festivities. They also worked to make the reentry of veterans into town life as smooth as possible. A Veterans Civilian Council, which included delegates from the Hershey corporations and civic organizations, such as the Volunteer Fire Company, the Ministerium, and the Civic Club, was formed in 1944 for this purpose.

MILTON HERSHEY'S FUNERAL, OCTOBER 16, 1945. The Hershey Industrial School's Senior Hall, overlooking the factory and the town, was the site of Milton Hershey's funeral. Thousands of people came to pay their respects as his body lay in state that morning. Eight boys from the senior class were pallbearers. They were John Albright, Clyde Harman, Rome Owens, Elwood Scheib, Stephen Sekellic, Kenneth Steen, William Swingle, and Wilmer Wolfe.

THE HERSHEY BURIAL SITE, OCTOBER 16, 1945. Milton Hershey's remains were interred in the Hershey Cemetery next to the graves of his parents and wife. Gordon Rentschler, who had worked with Mr. Hershey for 30 years and was chairman of the board of the National City Bank of New York, sent a telegram summing up the man and his achievements:

> I admired him from the beginning. It was always an inspiration to see the way he calmly and quietly and tenaciously fought his way through one obstacle after the other until he achieved his big success. And it was an inspiration, too, to find that he measured success, not in dollars, but in terms of a good product to pass on to the public, and still more in the usefulness of those dollars for the benefit of his fellow men. His life and work will always remain a great inspiration to us all.

Seven

THE POSTWAR YEARS
1946–1969

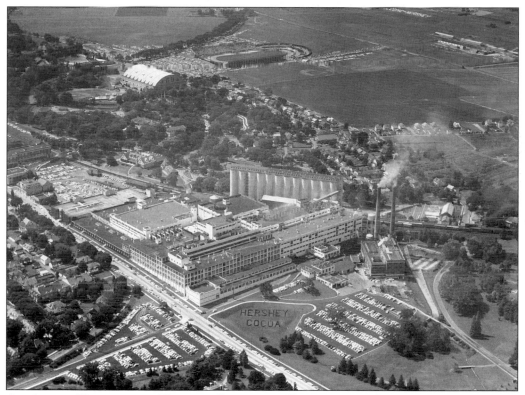

AN AERIAL VIEW OF THE HERSHEY CHOCOLATE FACTORY AND ENVIRONS, EARLY 1960S. When this picture was taken, the town still looked much as it had at the end of Milton Hershey's life, almost 20 years before. Additional parking lots around the factory and the huge cocoa bean silos erected on its northern side were the most notable changes. Note the Hershey Stadium and the arch-roofed Hershey Sports Arena—both built before World War II. Barberry bushes spelling out "Hershey Cocoa" have stood in front of the factory since 1909.

At first, the loss of Milton Hershey did not seem to make much of a difference to the corporations and the town. Hershey had handpicked his successors, and the mandate seemed clear to them. They were to maintain a profitable company that produced a high-quality product, a model town, and a first-rate school for orphans. In the years immediately following Hershey's death, it seemed as though the way to do this was to keep things the way they were when Milton Hershey was alive. As time passed difficulties arose, for the world was becoming a very different place from the one he had known.

Townsfolk and tourists alike were developing expectations and values different from those they had before the war. The business climate was becoming more competitive and the economy more complex. Government at all levels was becoming more directive. All of these factors made it more complicated and more expensive for a private organization to be benefactor, developer, owner, and manager of almost everything in a town, even a small town. Hershey was no longer one man's town, and inevitably it was starting to become, in these postwar years, less of a company town as well.

The Hershey Chocolate Corporation prospered in the booming postwar economy. Demand for its products was greater than ever. Throughout the postwar period, sales continued to climb and profits grew—but not as fast, because expenses also were growing. As postwar inflation increased, the union successfully demanded higher wages. Most negotiations were worked out peacefully. However, a month-long strike in 1953 illustrated the growing strength of the union. There were no more strikes during the postwar period, but pay raises continued and a union shop was in place by the end of 1969. The increasing cost of labor was only one reason for rising expenditures. The cost of raw materials, especially of cocoa beans, continued to rise. Large capital outlays were necessary to keep production levels up. New machinery and new buildings were added to the factory complex in Hershey. In the 1960s, the corporation began to invest in expanding its scope as well. It purchased the H.B. Reese Candy Company in Hershey, bought and developed huge almond plantations in California, and for the first time began to manufacture chocolate products outside of the town. Two new factories were built: one in Canada and one in California. In addition, a chocolate manufacturing venture in Mexico was begun in 1969. During the 1960s, the corporation also began to diversify, buying up pasta companies and a restaurant supply company. In 1968 it took on a new name, the Hershey Foods Corporation, which better reflected its holdings.

The town also felt the effects of the burgeoning postwar economy. Hershey was once again a sought-after meeting place for business and professional groups. More tourists than ever before came to enjoy Hershey Park, the factory tour, and Hershey's other attractions. The influx of visitors created parking and traffic problems in the middle of town, for the automobile was now the dominant form of transportation for both workers and tourists. As the need for parking space increased in the first few years after the war, parking lots were built on all sides of the factory, replacing landscaped spaces and residential buildings, making the town look less green and open. The town, however, still seemed to continue very much as before. Hershey Estates still owned the utility companies, almost all of the businesses and tourist attractions, and most of the recreational facilities. During the next ten years, Hershey Estates was mainly involved in renovating and refurbishing these holdings and running them more or less as they always had.

By the 1960s, it became clear that changes would be necessary to meet the changing times. Some of the key old buildings on Chocolate Avenue were deemed beyond repair. The old Cocoa House, now being used as a women's club, the post office building that had housed the original firehouse, and the Farm Implement Building all were torn down and modern structures were raised in their place. Some of Hershey Park's landmark attractions, such as the swimming pool, became too expensive to maintain and had to be demolished. The park began to seem somewhat old-fashioned—some of its amusements were less appealing to modern tastes and it was having difficulty handling an increasing number of visitors. Increased demands on the town's utilities and the growing need for capital expenditures to modernize them made them less economical for Hershey Estates to run. By 1965, the Hershey Electric Company had

stopped producing its own power and in 1969, the Hershey Telephone Company was sold to an outside concern.

Control over town growth by the Hershey Chocolate Corporation, Hershey Estates, and the Hershey Trust Company, still the township's major property owners, lessened only as the postwar era drew to a close. During most of this period, it was the board of Hershey Estates that made the major decisions about what kinds of development would take place and where. Preference for residential purchases continued to be given to Hershey employees and residents of Derry Township. All new home builders still had to have their house plans approved by Hershey Estates. By the end of the 1960s, state legislation had been passed that forbade such restrictions and gave more power to township authorities.

During the 1960s, the philanthropic contributions of the Hershey Chocolate Corporation to the town took a new turn. Milton Hershey had subsidized every public school building in his town since 1906. However, the corporation was no longer in a position to finance the larger schools needed to hold the children of the postwar baby boom. For the first time in the history of the town, bond issues were floated to finance the expense of building new public school structures. The Hershey Junior College also was becoming a financial burden to the corporation and had its final commencement in 1965. The corporation's grand finale gift to the town was the Cocoa Avenue Plaza, a splendid million-dollar recreational complex on the edge of town. Built in 1963 and enlarged in 1967, it included a multipurpose building, tennis courts, and two swimming pools. A new organization, the Hershey Recreation Center, funded by the M.S. Hershey Foundation and managed by Hershey Estates, ran both the Cocoa Avenue Plaza and the downtown Hershey Community Center recreational programs.

The major philanthropy of Milton Hershey, the Hershey Industrial School (renamed the Milton Hershey School in 1951), continued to flourish throughout the postwar period. During this time, the school encountered a unique problem that was to plague it into the next century. Milton Hershey had left it with such extraordinary financial resources that the Hershey School Trust generated more income than the school could spend. Even with an ambitious building and renovation program in the works and a generous operating budget, a large surplus had accumulated by the 1960s. Expansion was not an option, as the board felt that the current school size was in the best interest of the students. Therefore, another philanthropic venture in keeping with Milton Hershey's interest in education and the well being of others was sought. In 1963, the Dauphin County Orphan's Court approved a petition to allow the donation of $50 million and 100 acres of land to Pennsylvania State University to build a medical school and an "outstanding hospital" in Derry Township. After four years of intensive planning and the input of an additional $21 million of federal monies, construction began. A huge, crescent-shaped building just to the southwest of the town of Hershey started to take shape. In the fall of 1967, 40 medical students started their classes in the partially completed building. As it grew, the Milton S. Hershey Medical Center was to play a major role in the dramatic changes that took place in the Hershey community in the coming years.

THE LAST TROLLEY RIDE, DECEMBER 21, 1946. By the end of World War II, the trolley had outlived its usefulness for transporting milk, workers, and area residents. Many mourned its inexpensive, frequent, and dependable service; others were glad to see the last of the sparks, noise, and swaying cars.

PROF. WILLIAM SCHMEHL AND CLASS, THE HERSHEY JUNIOR COLLEGE, 1950S. The Hershey Junior College was a special asset in Hershey that was supported by the Hershey Chocolate Corporation. Until 1965, it provided free education for township residents, Hershey employees, and graduates of the Milton Hershey School and Hershey High School. It graduated its last class in 1965, after merging with Harrisburg Area Community College.

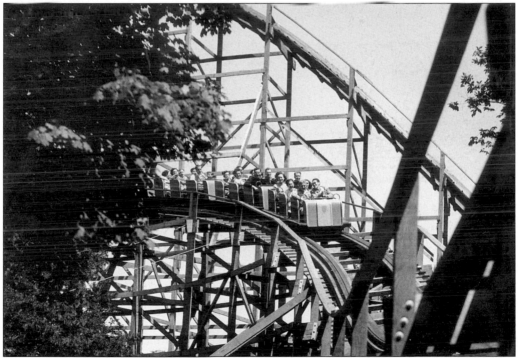

THE COMET ROLLER COASTER, HERSHEY PARK, C. 1946. This exciting new coaster was built to replace the park's original roller coaster, the Wild Cat, which lasted for 22 years but had deteriorated badly during the war. The Comet quickly became one of the star attractions in Hershey Park.

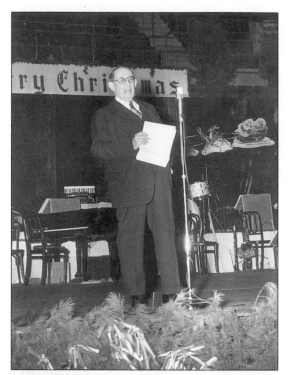

P.A. STAPLES AT THE HERSHEY EMPLOYEE CHRISTMAS PARTY, DECEMBER 1949. Milton Hershey handpicked P.A. Staples, formerly in charge of Hershey's Cuban enterprises, to succeed him as head of all of the Hershey entities. An able, if conservative manager, he had little interest in the model company town concept. His major concern was that Hershey enterprises remain profitable in order to fund the Hershey Industrial School.

THE HERSHEY CHOCOLATE CORPORATION SILOS UNDER CONSTRUCTION, 1950. Sixteen 130-foot-high silos were built to store cocoa beans. They dominated the north side of the factory and became a new landmark in town. More were added in 1957. The silos provided storage for "protective inventories" of cocoa beans, making the corporation less vulnerable to swings in cocoa bean prices.

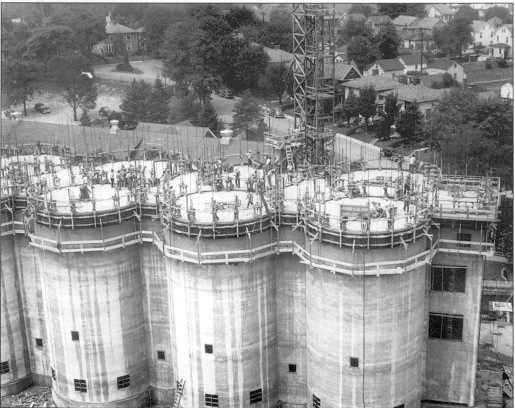

A Dining Car, Hershey Chocolate Strike, 1953. Non-striking workers are shown in a Pennsylvania Railroad dining car that was rented to provide meals for them during the month-long strike. The 1953 strike caused long-lasting bitter feelings between some of the strikers and non-strikers. (Courtesy of Derry Township Historical Society.)

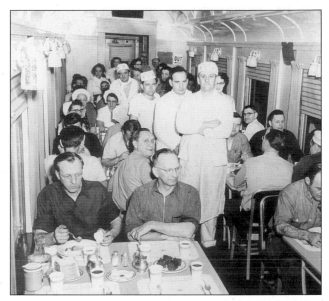

Chocolate Avenue, October 13, 1953. The town was decked out for a visit from Pres. Dwight D. Eisenhower, who came to celebrate his 63rd birthday in the Hershey Sports Arena. His birthday party was one of many events held throughout 1953 to help commemorate the town's 50th anniversary. Note the Hershey Women's Club (formerly the Cocoa House) across the street.

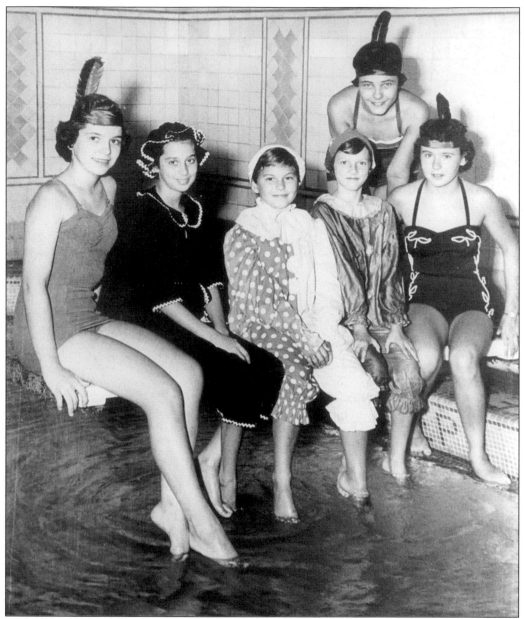

THE HERSHEY WOMEN'S CLUB WATER BALLET, C. 1954. The club rented rooms to women (mostly schoolteachers) and was a center of social, club, and sports activities for Hershey women and girls. In the late 1950s, the Optimist's Club sponsored a teen canteen in the Hershey Women's Club gym. Pictured, from left to right, are Joanne Lewis, Nancy Wilson, Sharon Pool, Linda Wilson, Ann Herriot, and Ardith Curry. (Courtesy of Derry Township Historical Society.)

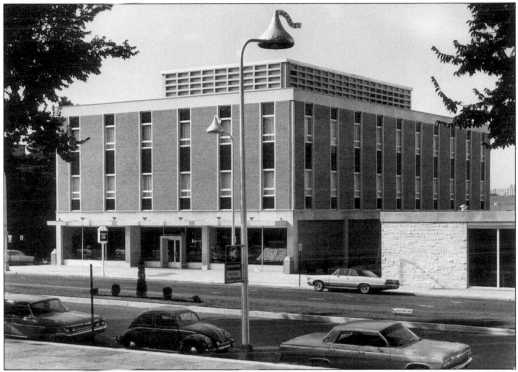

ONE CHOCOLATE AVENUE, C. 1965. Downtown Chocolate Avenue got a new look in 1963, when the Women's Club—housed in the first building to be erected after the factory—was razed. A building to house the drugstore and the Hershey Estates offices replaced it. The same year, the old street lamps were replaced with the Kiss-shaped street lights, which have since become a Hershey tradition.

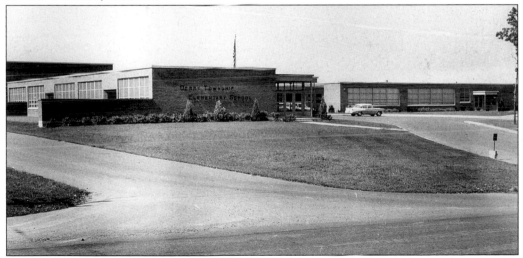

THE MILTON S. HERSHEY ELEMENTARY SCHOOL, 1950S. Milton Hershey's interest in education led him to underwrite the cost of all the community's public school buildings constructed in Hershey during his lifetime. Continuing that tradition, the M.S. Hershey Foundation presented this building as a gift to the township in 1954. It was the last public school building funded by the Hershey entities.

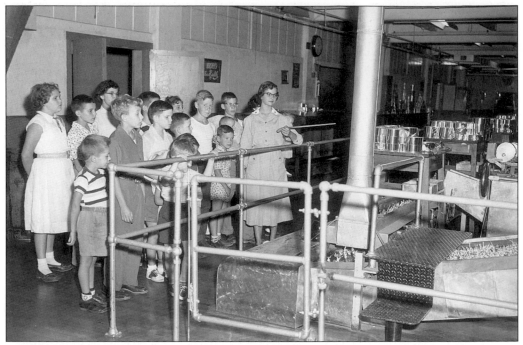

A HERSHEY CHOCOLATE FACTORY TOUR, 1960s. During the postwar period, tour visitation rose dramatically from 37,000 in 1946 to 740,000 in 1968. Local citizens avoided Chocolate Avenue during the summer because of traffic congestion caused by visitors coming to tour the chocolate factory.

THE MONORAIL, HERSHEY PARK, AUGUST 1969. This elevated ride was built in 1969 to help ease traffic congestion in downtown Hershey. Tourists could park near the Hershey Sports Arena, get a bird's-eye view of the park and town, get off at the Chocolate Avenue station, tour the factory, and ride back again.

A QUILTING DEMONSTRATION, PENNSYLVANIA DUTCH DAYS, C. 1966. Pennsylvania German language students in a Derry Township public school evening class had the idea of starting Pennsylvania Dutch Days. Each summer, starting in 1949, the festival was held in the Hershey Sports Arena. It attracted large numbers of tourists, who came to see traditional craftsmen at work, to eat Pennsylvania Dutch food, and to hear Pennsylvania Dutch comedians perform.

THE ANTIQUE AUTOMOBILE SHOW, 1967. The national headquarters of the Antique Automobile Club moved to Hershey in 1959. Every October since then, the club's annual show and flea market has been held in the Hershey Stadium and in the fields and parking lots surrounding it. Thousands of enthusiasts throng to this event each year.

THE HERSHEY MOTOR LODGE, LATE 1960S. Hershey Estates built this large motel on the west end of town in 1967. Its 200 rooms helped to accommodate the increasing number of tourists pouring into Hershey by car during the postwar years. The location was within easy driving distance of all of the Hershey tourist attractions.

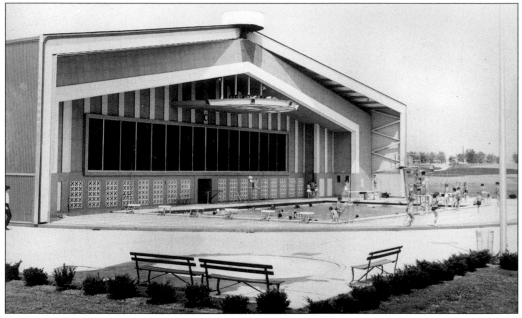

THE COCOA AVENUE PLAZA, C. 1967. This indoor-outdoor pool has a unique retracting roof. The pool is an important part of a recreational complex built by the Hershey Chocolate Corporation for Derry Township residents in 1963. An Olympic-sized outdoor pool was added to the complex in 1967 to offset the loss of the Hershey Park pool, which was beyond repair and had been closed the year before.

THE NEW STATE POLICE ACADEMY, 1960. For 34 years, the State Police Academy had been located on Cocoa Avenue. When it outgrew that facility, Hershey Estates, eager to keep the academy in town, donated land for a new building on a hilltop north of the chocolate factory.

THE NATIONAL PLOWING CONTEST AND PLOWING EXPOSITION, AUGUST 1968. Hershey Farms often hosted state and national agricultural events. The farms were well known for using responsible and innovative farming techniques. As the largest single diversified farming operation in Pennsylvania, Hershey Farms had the largest individual farm acreage in the Pennsylvania Soil Conservation Program during the postwar years.

DR. GEORGE T. HARRELL, THE MILTON S. HERSHEY MEDICAL CENTER, 1967. Dr. Harrell, the first dean, points to a model of the Pennsylvania State University College of Medicine and University Hospital, as the building rises in the background. Hershey became a focus of interest for the national medical community as the innovative Hershey Medical Center took shape. (Courtesy of Milton S. Hershey Medical Center.)

THE DATESTONE CEREMONIES, MEDICAL SCIENCES BUILDING, THE MILTON S. HERSHEY MEDICAL CENTER, APRIL 30, 1968. A total of $50 million of accumulated funds from the Milton Hershey School Trust was donated to start the Hershey Medical Center. Standing, from left to right, are Dr. Harrell, Gov. Raymond Shafer, Dr. Eric Walker, Samuel Hinkle, John Minnich, Elmer Ritter, J.O. Hershey, James Bobb, and Russell Ritter. The man with the trowel is Roy Larson.

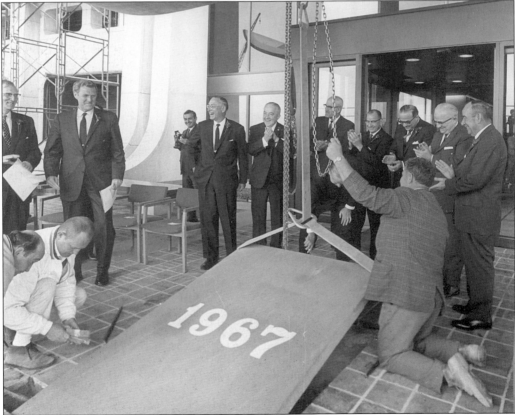

Eight

MILTON HERSHEY'S LEGACY 1970–2000

THE HERSHEY CHOCOLATE FACTORY AND CHOCOLATE AVENUE, 1987. Much has changed in Milton Hershey's town since 1970. Old buildings have been torn down or put to new uses. Many new homes and commercial enterprises have been built. Public school buildings have been expanded and a new high school built in response to a growing population. Although the various Hershey entities remain an important part of the community, they are no longer its main support and service providers. The township and private citizens take an increasingly active role in running the community.

Hershey has continued to evolve along the basic outlines developed by its founder. Milton Hershey strove to build a successful company with reasonably contented workers. He developed a town that was attractive to look at, enjoyable to live in, and a good place to raise and educate children. He encouraged the development of tourism. Above all, it was of major importance to him that the profits of his enterprises be used for the good of others. In particular, it was a primary concern that the needy children in his school be well provided for. All of these things Hershey accomplished as a man of his time and with the stamp of his own personality. All of them exist today, although the means of accomplishing them and the form they have taken underwent some fundamental changes in the period from 1970 to 2000.

The size and nature of Derry Township's population changed rapidly after the opening of the Milton S. Hershey Medical Center in the early 1970s. It brought an influx of medical professionals and students with a wide range of outlooks and diverse religious and ethnic backgrounds. The township's population grew from 15,500 in 1970 to 20,500 in 1998. This increase was due in large part to the growth of the Hershey Medical Center. Over the years, many millions of dollars have been invested in new facilities for research and patient care. In the 1990s, the medical center emerged as one of the township's largest employers, with more than 6,000 employees. As it developed, the medical center added a new dimension to Hershey's reputation. The town gained stature as the home of an excellent medical school, research center, and teaching hospital.

One result of Hershey's population growth has been that about 60 percent of township land has been built up with private residences and commercial enterprises. The remaining 40 percent is owned by the Hershey entities. The Hershey Trust Company's decisions concerning land use will direct the future of development in Derry Township. To date, the trust company remains committed to limited development, maintaining most of its holdings as farmland and open space, giving the town a green and rural setting.

The Hershey corporations originally founded by Milton Hershey are still a major factor in township decisions. Their extensive land holdings, as well as their role as major employers, important taxpayers, and extensive users of utilities and resources, continue to make their decisions and actions of key importance to Derry Township. Their corporate boards, however, are no longer the sole arbiters in directing community affairs. Today, they work with the local township government and other organizations that are now responsible for providing public services such as road maintenance, recreational facilities, water, utilities, and land use planning.

In 1970, Hershey Estates was still almost solely responsible for providing Hershey with services, utilities, and recreational opportunities. By the early 1980s, most of its enterprises and services had been either sold to commercial companies or turned over to the township or the M.S. Hershey Foundation. Hershey Estates began to concentrate on developing its hotels and Hershey Park. Its 1976 name change to HERCO Inc. (now Hershey Entertainment and Resorts Company) reflected this new purpose. Hershey Park was renamed Hersheypark in 1971 and redeveloped as a theme park. For the first time, it was fenced in and a general admission fee was charged. New rides, entertainment, and landscaping were added. It was a winning strategy— attendance rose rapidly. Development of Hershey as a tourist destination was hindered during the next ten years by several local disasters. A major flood, the malfunction of a nearby nuclear power plant, and a polio epidemic distressed local residents and discouraged tourism. These events caused HERCO executives to question the wisdom of tying their company's success to one geographic location. In an effort to broaden the reach of the company, HERCO made a number of major investments in out-of-town hotels and attractions. The investments failed to protect the company, and the outside ventures were soon sold. By the late 1980s, it began to concentrate, once again, on its core Hershey businesses. Money was infused into Hersheypark and the resorts, adding new rides and attractions, and expanding and upgrading the hotel and the lodge. By 1996, annual Hersheypark visitation exceeded 2 million. The company has continued the tradition of bringing nationally known sports and entertainment to Hershey, with an increasing number of offerings at the arena and the stadium. As a result, Hershey's

reputation as a destination for tourism as well as for conventions and meetings has continued to grow. Hershey Entertainment and Resorts Company is important to Derry Township's economy. It is the largest real estate taxpayer in the township, and 10 percent of its ticket sales go to help support the local public school system and township operations.

Hershey Foods Corporation has grown rapidly in the past 30 years. Continued modernization of the corporation's business practices and technology, plus acquisitions and the development of new products, caused its net sales to soar from $334 million in 1969 to $4.4 billion in 1998. While Hershey Foods operations expanded into other locations in the United States and abroad, its physical presence in Hershey has also grown. Four new facilities were constructed locally: a state-of-the-art manufacturing plant, a technical center, a new complex for corporate administration, and a 1.2-million-square-foot distribution center. In addition, the corporation also maintains its downtown presence, occupying the former Hershey Community Building and continuing to manufacture products in the original factory. The corporation still contributes to worthy causes in the town and occasionally makes particularly handsome donations, such as Chocolatetown Square, a new community park, in the town center. But as a result of its expansion to so many other locations, Hershey is no longer the only focus of its corporate contributions. The original factory, however, continues to contribute its most unique gift to the town of Hershey: a heady chocolate aroma.

By the early 1970s, factory tours for the public raised health and safety risks for the plant, and visitors increased downtown traffic congestion. In response, Hershey Foods built Hershey's Chocolate World in 1973. This visitor center, near the entrance to Hersheypark, offers a simulated tour ride of the chocolate factory. Chocolate World, originally built as a public service for visitors, soon became profitable through restaurant and merchandise sales. Chocolate World, Hersheypark, and the other local attractions now bring more than 4 million visitors a year to Hershey.

The Milton Hershey School, beneficiary of these Hershey enterprises, continues to serve needy children. However, it too has seen many fundamental changes in the past 30 years. The original Deed of Trust was modified to allow the enrollment of girls, students of all races, and children whose parents are unable to care for them. Emphasis on agricultural and other vocational types of education has given way to a more academic curriculum, and much of the school's farmland is now leased to neighboring farmers.

As with the other Hershey entities, the Milton Hershey School's institutional culture has evolved and modernized. The school's managing board and administrators now solicit input from a variety of groups to guide decision making. Houseparents, teachers, and operations personnel are represented by unions. The school also encourages parents to be partners in the care and achievement of their children. Alumni serve as student mentors and role models. In 1995, the school embarked on a major plan for campus reorganization. The plan called for major new facilities—including a high school, a middle school, a learning resource center, a visual arts center, and a performance gymnasium—and an expanded elementary building and student center, all to be clustered in a campus town center with new student housing built in nearby neighborhood clusters. The school planned to increase its enrollment from 1,100 to 1,500 students.

In spite of the challenges of changing times, the Milton Hershey School, the corporations, and the town have all survived and prospered since the death of their founder more than half a century ago. It is a tribute to Milton Hershey's foresight, to the cooperative efforts of those who have followed him in running the Hershey entities, to the officials of Derry Township, and to the people who live and work in the area that his legacy continues.

THE IMPLOSION OF THE COCOA INN, DECEMBER 29, 1970. This building, on the corner of Cocoa and Chocolate Avenues, was a landmark in Hershey for 60 years. During that time, it provided lodging for tourists as well as for visiting teams and performers. Townsfolk waited for the trolley there and met for social gatherings. By 1970, when the board of Hershey Estates reluctantly decided that the building should be razed, it was no longer profitable. A sinkhole was undermining its foundations. New motels and restaurants in the area, including the Hershey Estates Motor Lodge, offered modern accommodations with more convenient parking. (Courtesy of Lebanon Daily News.)

HERSHEYPARK DRIVE, JUNE 1972. Tropical storm Agnes, the worst natural disaster in the history of Pennsylvania, caused serious flooding in the central region of the state. Many Hershey roadways, as well as homes and businesses, were inundated. The chocolate factory's power plant was flooded. For several days, Hershey Chocolate milk tank trucks took water from a well on the Milton Hershey School campus to supply township residents with safe drinking water.

THE HERSHEY SPORTS ARENA, APRIL 1979. When the Three Mile Island Nuclear Plant (located 10 miles from Hershey) malfunctioned, authorities recommended that pregnant women and preschool children within a radius of 5 miles evacuate. The Hershey Sports Arena was the designated evacuation site. Until the situation stabilized, 186 people lived there. Approximately 144,000 residents within a 15-mile radius of the plant evacuated the area altogether during this crisis. (Courtesy of Dauphin County Historical Society.)

MEMBERS OF HERSHEY FOODS CORPORATE STAFF, HIGH POINT, DECEMBER 1984. Vacated by the Hershey Country Club in 1970, High Point remained empty until 1978. It was renovated by Hershey Foods as offices for its corporate staff, some of whom are shown relaxing at a Christmas luncheon. After Hershey Foods built its new corporate headquarters in 1991, the Hershey Trust Company offices moved into High Point.

MILTON HERSHEY'S GOLF CLUBS, THE HERSHEY COUNTRY CLUB, C. 1974. The Hershey Country Club's new facilities east of town included a driving range, a golf course, a curling rink, a swimming pool, and tennis courts. In 1994, HERCO sold the club, along with its other golf courses, to a private concern. Pictured, from left to right, are James Bobb, Jay Weitzel, and Fritz Miller.

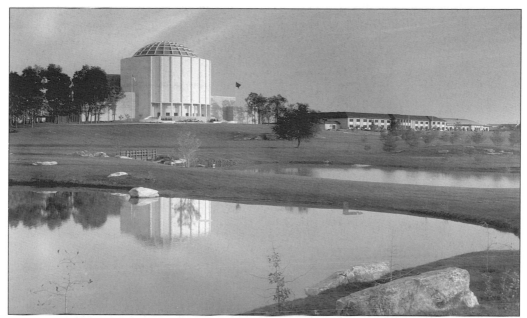

FOUNDERS HALL, 1970. Erected as a memorial to Milton and Catherine Hershey, this building is used as administrative offices for the Milton Hershey School. Its dining facilities and 2,600-seat auditorium are used for both school and community functions. In the Hershey tradition of building facilities with exceptional architectural features, Founders Hall boasts the second largest rotunda in the world.

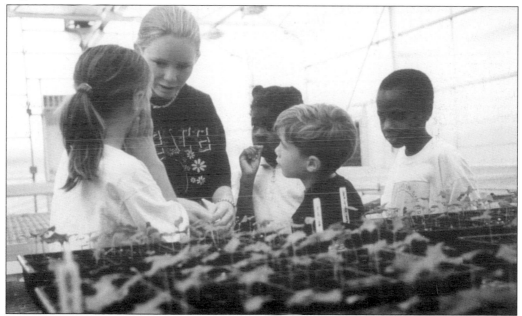

THE HORTICULTURAL CENTER, THE MILTON HERSHEY SCHOOL, 1999. The agricultural and environmental education program at the Milton Hershey School provides both academic and vocational training for students. This state-of-the-art facility, dedicated in 1998, and an Environmental Center are central locations where students work individually and in groups. (Courtesy of Milton Hershey School.)

121

THE CORPORATE HEADQUARTERS OF THE HERSHEY FOODS CORPORATION, 1999. This building complex was erected on a 174-acre site north of the factory in 1991. The new facility centralized Hershey Foods Corporation's widely dispersed corporate administrative offices and technical support services. (Courtesy of Hershey Foods Corporation.)

THE EXECUTIVE BOARD, CHOCOLATE WORKERS LOCAL 464 OF THE BAKERY, CONFECTIONERY, TOBACCO WORKERS, AND GRAIN MILLERS INTERNATIONAL UNION, APRIL, 2000. Union membership has been required of all Hershey Chocolate workers since December 1969. Pictured in the front frow, from left to right, are Dennis A. Bomberger, business agent; F. Jay Hostetter, president; Robert D. Feaser, business manager; William K. Sprandel, financial secretary and treasurer; Melvin C. Myers Jr., vice president; Bruce R. Hummel, business agent; and Diane E. Carroll, recording secretary. (Courtesy of Chocolate Workers Local 464.)

HERSHEY'S CHOCOLATE WORLD, 1999. The Hershey Foods Corporation built Hershey's Chocolate World in 1973 to replace visitor tours through the factory. The facility offers a ride through a simulation of Hershey chocolate production, as well as restaurants and shops where Hershey products and souvenirs can be purchased. By 2000, more than 50 million visitors had toured Chocolate World. (Courtesy of Hershey's Chocolate World.)

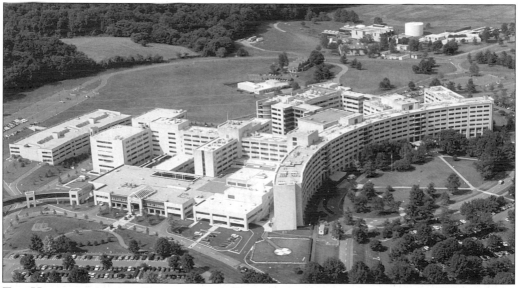

THE HERSHEY MEDICAL CENTER, 1999. Research, teaching, and patient care facilities of the Hershey Medical Center have grown considerably since 1970. The medical center serves as both a referral center and a primary care facility. It continues to be the home of the Pennsylvania State University College of Medicine. (Courtesy of Milton S. Hershey Medical Center.)

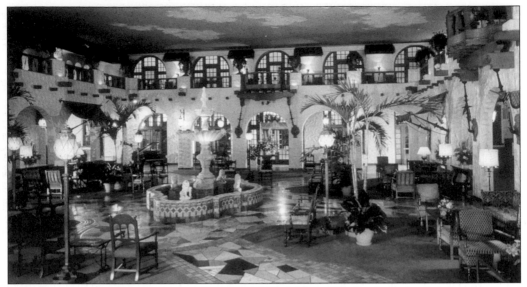

THE HOTEL HERSHEY, FOUNTAIN LOBBY, 1999. Milton Hershey's prediction that his hotel would eventually become a financial success proved to be a reality. Groups and individuals desiring secluded elegance seek it out. Area residents celebrate special occasions there. The preservation of the hotel's historic integrity, in spite of renovations and expansion, has earned it a place on the National Trust for Historic Preservation's list of Historic Hotels. (Courtesy of Hershey Entertainment and Resorts Company.)

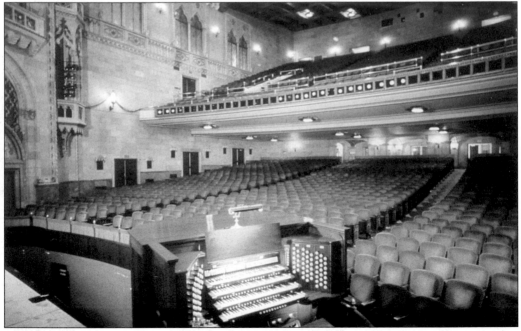

THE HERSHEY THEATRE AUDITORIUM, 1999. In the 1980s, the Hershey Theatre, the Hershey Museum, and the Hershey Gardens, were turned over by HERCO to the M.S. Hershey Foundation, which manages and partially endows them. These three nonprofit institutions, along with the Hershey Community Archives, help to continue Milton Hershey's legacy of cultural enrichment for the town. (Courtesy of Hershey Theatre.)

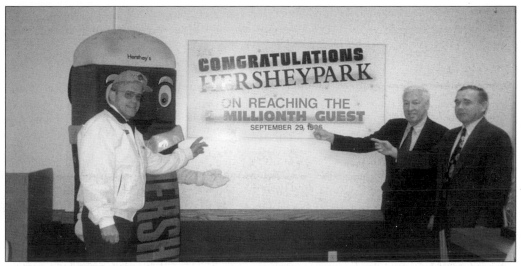

CELEBRATING HERSHEYPARK'S ATTENDANCE RECORD, 1996. Hersheypark has continued to be a prime attraction in Hershey. Theme areas, the renovation of the zoo, the regular addition of exciting new rides, a two-month-long Christmas Candylane celebration each winter, and lively shows and concerts have all helped the park maintain its appeal. Pictured, from left to right, are HERCO executives Franklin R. Shearer, J. Bruce McKinney, and Todd Pagliarulo. (Courtesy of Hershey Entertainment and Resorts Company.)

FACE PAINTING, HERSHEYPARK, 1999. Since its inception in 1907, Hersheypark has been a source of seasonal jobs for large numbers of teenagers and young adults. Many Hershey area youths gain their first work experience at Hersheypark. More than 2,600 seasonal workers were hired by Hersheypark in 1999. (Courtesy of Hershey Entertainment and Resorts Company.)

THE HERSHEY PUBLIC LIBRARY, 1999.
A community venture since 1912, the library received liberal support from Milton Hershey. It also served the Hershey Junior College, as well as the community, from 1938 to 1965. The M.S. Hershey Foundation transferred the library's assets to Derry Township in 1981. In 1997, the library moved into its first freestanding facility. Pictured are volunteers Frances DiClemente, left, and Jessie Kunetz. (Courtesy of Hershey Public Library.)

A HERSHEY WILDCATS SOCCER CLINIC, 2000. With the addition of the Hershey Wildcats outdoor soccer team to HERCO's holdings in 1997, regular professional soccer games were instituted at the Hershey Stadium. Wildcats team members also provide a summer soccer camp and soccer clinics for area youngsters. In this picture, Wildcat player Matthew Ford puts local youngsters through their paces at the select training school. (Courtesy of Simonetti's Freelance Photo.)

THE HERSHEY ITALIAN LODGE DINING ROOM, 1990S. Organized as a Mutual Benefit Society in 1920 by Italian immigrants living in Swatara, the Hershey Italian Lodge became a center for area Italian community events. A larger building was constructed in Hershey in 1950. Expanded and renovated several times since then, the lodge is still a meeting place for Italian Americans but also has many social members of all backgrounds. (Courtesy of Hershey Italian Lodge.)

THE SHANK BARN, 1998. Located in a 90-acre park belonging to Derry Township, this barn was rebuilt after it burned down in 1997. The township now owns and operates other recreational facilities, including Cocoa Avenue Plaza (now Hershey Recreation Center), which was transferred to the township by the M.S. Hershey Foundation in 1979. (Courtesy of Hershey Chronicle.)

HERSHEY HIGH SCHOOL, 2000. The focal point of community life in Hershey has shifted from the crossroads of Chocolate and Cocoa Avenues to a 135-acre site one-half mile south of downtown. The high school, built in 1996, is situated on one end of this site. The township's other public schools, Memorial Field playing fields, the Hershey Recreation Center, and the Hershey Public Library are all located here. Each of these institutions has its origin and history rooted in Milton Hershey's vision for the town. Each has grown beyond his initial support as the result of the continued work that Hershey citizens put into their community.